Another America

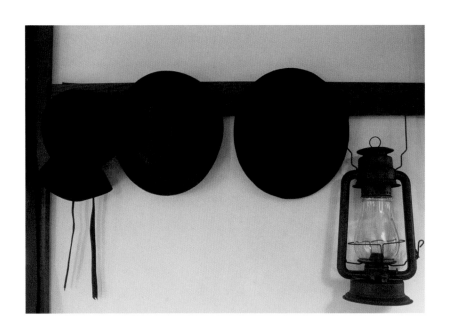

Robert Weingarten

Another America

A Testimonial to the Amish

Steidl

For Palomba

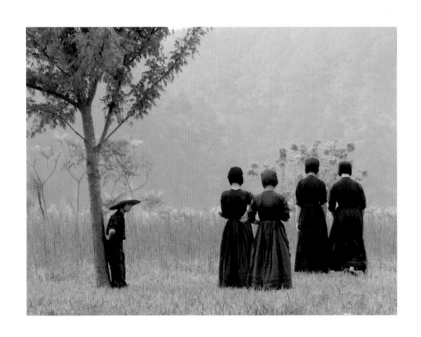

Robert Weingarten: Amish Landscapes

A long and straight trajectory extends across the geometries of a landscape somewhere in Lancaster County, Pennsylvania. An unseen road bed divides the scene into equal measures of top and bottom: trapezoids of ochre and green fields below, a rectangle of hazy light blue sky above. Near the precise center of the image a silhouetted horse and buggy proceed apace towards some destination to the right, the conveyance and its unseen occupants stilled within the outline of distant hills. It is a landscape scene that is at once simple and dramatic, rational and felt, casual and considered.

For four years Robert Weingarten, the photographer of this scene, has documented the Amish communities of the United States. In precisely seen images—images that are carefully designed and composed—he graphically articulates a rural America seldom seen or appreciated, an America that is self-reliant and set apart from modern times, and an America in large part devoid of such incidentals as telephone poles and billboards. His approach is sympathetic to communities that wish to remain relatively undisturbed by outsiders, his style is a blend of pictorial and modernist photography, and his eye is one that distills the essence of a place and its facts.

A long and straight trajectory also extends across Weingarten's career, beginning from growing up in Brooklyn, New York, where he was born to a working-class family in 1941. In public high school he excelled in history, science, and mathematics and pursued a love for both music and photography. He is fond of telling the story of his guidance counselor's one-word response to him saying he did not want to be poor and loved photography; that response was simply—"Choose!"[1] Earning a business degree from Baruch College of what is now City University of New York, he became highly successful in publishing and international finance. Over the years he collected the very finest cameras, and in 1991 his wife, Palomba, gave him a complete darkroom for their Los Angeles home as a fiftieth-birthday gift. Not until five years later, in 1996, did Weingarten begin gradually stepping back from his businesses to devote progressively more time to becoming a photographic artist.

Fast track is to say the least. Weingarten studied with professional photographer Charles Waite in Newcastle, England, to learn the craft's techniques, and traveled extensively through North America and Europe, where he photographed pastoral landscapes in color—Cumbria in England, Tuscany in Italy, and Provence in the south of France. In 1997, becoming dissatisfied with standard color prints, he was seduced by the fibrous papers and rich palettes available with computer-assisted Iris ink-jet prints offered by R. Mac Holbert at Nash Editions in Manhattan Beach. By the end of the decade he was represented by the Weston Gallery in Carmel, featured in professional trade journals, and appointed Associate of the Royal Photographic Society of Great Britain. Ultimately he was made Fellow of that Society in 2001. In 2000–2001, he discovered the magnificent rolling hills of grain and grasses in the Palouse region

of southeastern Washington state. "Timeless" landscapes, he calls them, unpeopled but with all the hints of being "touched by the hand of man."[2] Large-scale prints were made, and these were quickly acquired by American collections, both private and public. His work is currently represented by a number of galleries, including Marlborough Gallery in New York.

In April of 2001, Weingarten realized a desire to document another "timeless" landscape—the Amish country in Eastern Pennsylvania, which he had driven through as a younger businessman. Here was not only a landscape but a social community that was, as it were, arrested in time—no traces of industry, no telephone poles, phone lines, cars, buses, or paved sidewalks—an agrarian community situated as if relocated from centuries earlier. He became "enthralled," if not transfixed, by this fundamental landscape and its farms, vehicles, and people. Clearly, it had to be shot in black and white; he had to "depict them as if in the century in which they seem to be living."[3] Shooting analog (or chemical, normal film), he also knew it had to be printed digitally through the Iris printer, since it could guarantee a grayscale similar to the platinum/palladium prints so fashionable in the early twentieth century.

British filmmaker John Grierson coined the phrase "documentary photography" in the 1930s and wrote about a "new language of apprehension." According to him photographing any real condition or, in other words, real life required "something more in the nature of a dramatic language than a rational one" in order to communicate the quintessence of facts.[4] Grierson was later characterized by the American photographer Walker Evans as an important practitioner of "lyric documentary."[5] Weingarten's photographs of Amish farmlands are surely lyrical and even dramatic. At no time is he clinically detached or disinterested; at all times he is deliberating and passionate about rendering what lies before him in the best possible way to communicate its essential "thereness."

In this project Weingarten restricted himself to predominantly Old Order Amish settlements, avoiding both Quaker and Mennonite communities. The Amish originated as a splinter sect of the Swiss Mennonites during the Protestant Reformation and began settling in Lancaster County, Pennsylvania, in the early eighteenth century, with other groups later establishing themselves in New York, Ohio, Indiana, Illinois, Iowa, and Wisconsin. Amish communities are now found in other states as well and in Canada. Wishing to preserve the values and lifestyles of late seventeenth-century European rural culture, they reject most of the technical developments of modern society and periodically conduct conferences devoted to the problems and pressures of modernization. Traditional Amish shun the automobile, preferring horses and carriages; they do not have electricity in their homes, have only gravity-fed plumbing, and have their children attend private, one-room schoolhouses up to but not beyond the eighth grade. In 1972, the Supreme Court ruled unanimously that it was unconstitutional to force Amish children to attend high school.[6]

There are many Amish communities and they vary considerably; some are more liberal and others more conservative. Debates centering on use of the telephone took place between the Amish Mennonites or "Church" Amish and

the more traditional Old Order or "House" Amish in Lancaster County between 1905 and 1910. In 2003 Old Order Amish in Chautauqua, New York, defied a new fire ordinance specifying a minimum size to house windows some two square inches larger than traditional Amish windows. According to Mose Byler, an Amish bishop, "If you break a tradition, where's the tradition?"[7] And then there is the matter of the Amish tradition proscribing photography, a modern technology for the making of images.

In general, most commentary and opinions about the Amish's aversion to photography cite the Old Testament's second commandment, "Thou shalt not make unto thyself a graven image," and what could be more graven than an image made by a camera? But some Amish have calendars, books, and magazines with pictures in them; many have classroom and wedding pictures of themselves; and some even have mirrors in their homes.

According to the *Amish Country News*, an online journal vetted by local Amish in Lancaster County, general conferences of Amish ministers were held between 1862 and 1878 to reconcile differences in various districts. The minutes of an 1863 meeting in Mifflin County, Pennsylvania, has one Solomon Yoder opposing photographs. A meeting in Holmes County, Ohio, in 1865 issued a "Discipline of 11 Articles," in which article 3 disallowed the "carrying hidden on one's person photographic pictures of human likenesses or hanging them on the wall to look at in our houses." No mention of any scriptural basis is cited.[8] Donald Kraybill, a noted scholar in Amish and Mennonite studies, suggests that the second commandment was adopted to legitimize the proscription of photographs only in the late nineteenth century when photography became more popular.[9]

Still, many Amish firmly believe in and obey the second commandment, some have real fears that photography can steal one's soul, and most feel uncomfortable and annoyed at being treated as exotic others by tourists. Deference, then, should be the suggested route to take in documenting Amish communities by anyone: professionals and artists as well as tourists. In this regard Robert Weingarten is impeccably respectful and caring. Most of his images of people are of children, who are technically Anabaptists and not Amish until adult baptism; adults are treated more as figures in the bucolic landscape than as portraits of individuals; and all shots are taken in public settings from discreet distances. The imposition of the modern camera into the daily rituals of his subjects is scrupulously avoided to the best of the artist's abilities.

Correct photography needs to be responsible photography. That dramatic language of apprehension Grierson spoke of must still be honestly faithful to the subject at hand and to truthfulness in representation. In images that are carefully composed and perfectly balanced, Weingarten structures a very idiosyncratic vision, a picturesque vision that is lyrical, harmonic, and romantic. No postmodern irony or urban cynicism here, nor any complex theoretical program directing the story. Simply put, there is Weingarten's completely honest and personal enthrallment with this particular part of America.

Roland Barthes, the late French *philosophe*, announced rather strongly that all photographs are contingent, meaning there is something referenced, something represented.[10] Something, in other words, was in front of the camera when the exposure was made. Is the image true? Certainly. For a very brief fraction of a second the subject looked exactly like that from that vantage point and in that light. Is the image absolute truth? Not at all. It is always a specific selection from a continuum, a point of view, and a distillation of an essence. Still, when done exceptionally well, it can be artistically truthful since, as Grierson also claimed, the "quintessence will be more important than the aggregate."[11] In this sense, Weingarten's images of the Amish are about such a quintessence.

The nineteenth-century British photographer Peter Henry Emerson, famed for his naturalistic views of East Anglian farmers and fishermen, asserted that, "One thing you must never forget, that is the type; you must choose your models most carefully, and they must without fail be picturesque and typical."[12] In Weingarten's photographs the laborers in their fields are of a type, they cannot help but be. Because of the standardization of their dress code, the men sitting on the porch, the women walking down those roads, and the young girls striding to Sunday-morning services are prototypically "plain people" of this quintessentially Amish community. And just as the country roads in his pictures are typical and ordinary, so are the farms perfect ur-farms, eloquently sited in a rural landscape.

An unpaved road ripples across a couple of hillocks somewhere in Holmes County passing a few trees at the left. Bounded on both sides by fences, the road rises, descends, rises, and vanishes from sight over the second mound. In one of three photographs of this scene, two rearing horses cavort in the field to the right. In another image, taken from the identical vantage point, a small black Amish carriage recedes up the first hillock near the bottom of the scene. In a third photograph, an Amish woman, dressed in a black coat and white bonnet, walks along the left side of the road near the top of the first hillock and next to a tree. She is as unaware of the photographer some distance behind her as she is of the bird caught hovering just above a bare branch near the crest of the tree. Here, indeed, are three expressive studies of pastoral harmony.

A trotting horse pulling a carriage approaches Weingarten head on in Lancaster County; on other roads in the vicinity children recede into the distance pulling a tiny wagon or riding a simple scooter. In two studies of a black-topped road in Holmes County different groups of Amish on the way to a wedding ascend up the hill, punctuating the roadway as if in clusters of musical notations. And, in a balance of activities set against a backdrop of mature corn fields in Elkhart County, Indiana, two women slowly amble down a slightly declining road towards a crossroad on which a horse and carriage are seen quickly approaching the intersection.

Farmsteads in the East and Midwest are customarily set beside country roads or at least within sight of them. Two views of the open countryside in Lancaster County show the same farm using two different lenses some moments apart. While some other farms can be seen in the distance, the central one is a nearly perfect model of an ideal

farmstead. It is clean and brightly painted; there is a two-story house with attic windows, a Pennsylvania-style barn, two silos, and at least three utility buildings. The architectural complex is neatly framed by a delicate and pristine white picket fence. Almost storybook, to be sure, but well worthy of pictorial consideration.

Other examples of farm architecture are found in Weingarten's photographs, themselves models of composition. A swarm of dark black buggies is discovered parked in front of a bright white barn in Holmes County; while a white utility building in Washington County, Iowa, is placed to the right in counterpoint to a pile of dark hay bales at the left. Beneath heavy clouds and surrounded by dark hills and trees another farm at the bottom of a small dale in Holmes County has its reflective roofs and white picket fence brilliantly illuminated by what appears to have been a sudden burst of sunlight through the otherwise overcast sky.

One rainy Sunday morning, on only his second day photographing the Amish in Lancaster County, Weingarten fell upon a scene of wonderful proportions and near Cubist geometries. In one image black buggies are parked in front of a silo and two barns next to a shiny asphalt road, their circular wheels and dark rounded edges in sharp contrast to the severe white planes and volumes of the barns. Two men on the way to or from church services in another picture walk amid other buggies, a barn and its silo, a small milk house, and a farm wagon parked farther back to the left. Beneath the wagon and in the slight space between it and the milk house, almost overlooked, appear the legs and shoulder of a few Holstein dairy cattle. In a third and arguably more dramatic shot two young women are caught walking down a slope centered between the two barns and in the middle of three zones of gray: the light gray of the sky against which their dark clothes are contrasted, the dark gray of the lawn they are walking on, and the middle gray of the wet road at the bottom. Think Charles Sheeler or Johan Hagemayer in a way, but certainly more pictorialist.

A nineteenth-century British champion of pictorialist themes and effects in photography, Henry Peach Robinson, wrote that, "Landscape without a figure is a suggestion unfulfilled, a fitness unused, an opportunity wasted." He went on to stress that, "The figures should be not only *in* the picture, but *of* it."[13] Weingarten certainly adheres to this advice. In Lancaster County a farmer, seen from behind, stands atop a plow pulled by four large mules, a perennial trope for generations of painters, printmakers, and photographers in depicting agricultural labor. Seen dramatically in near silhouette, two farmers plow their fields in opposing directions in Monroe County, Wisconsin; and a woman hoes weeds in Bedford County, Tennessee. In Elkhart County, a woman who holds a pitchfork or another who knits are perfectly integrated in their landscapes along with their pet dogs. In what may be seen as some Surrealist mystery, four women in Bedford County stand motionless in a field for no apparent reason, their backs to us while a young boy leans against a tree watching them.

Nearly as surreal is the group of young girls in prayer standing still in the middle of a vast snow-covered field with heads bowed; so too the lone figure of a young boy running across the snow, the rear half of a female teacher

entering her one-room schoolhouse in Lancaster County, or the same teacher's upper body silhouetted and framed by the school's windows. A bit uncannily, two horses stand silently looking out of a barn door in Elkhart County, a farmhouse and barn are frozen in their reflection in absolutely deadened pond water, and a bird sits ruminatively atop the remains of a fence post set against an ominous yellow-orange sky in Holmes County.

While a number of Weingarten's images depict Amish women driving carriages toward unspecified destinations, others depict quite ordinary country ways, Amish or not: a mother holds her baby while standing in a meadow, men sit on porches, children are let out of school at the end of the day, and people attend country auctions. More upbeat still are the scenes of Amish at play and recreation: schoolgirls climbing atop a slide or playing volleyball in a field, children playing baseball, two women fishing in a rowboat. Ordinary details, what Weingarten calls "cameos," punctuate his Amish project as well: "hats and lanterns hung on a wall, laundry drying on lines in the open, quiet still lifes of school books and flowers in vases, corn cobs in cribs, and steel milk cans." The American poet William Carlos Williams said it rather well in 1946: "Say it, no ideas but in things."[14]

A long and not-so-straight trajectory has taken Weingarten across four years, six states, and numerous individual trips, returning often to the same communities to photographically document his vision of the Amish in America. That trajectory has also taken him across the challenges of contemporary photography over the past half-decade more or less. He began with a 35mm Nikon F5 film camera with a gyrostabalizer and ended up with an 11.2 megapixel Canon DS digital camera. When he began the project, digital imaging could not really compete with analog film; it was not fine and detailed enough. By 2004 it could, and he converted totally to digital. All recent work done in Tennessee and Iowa was done with the Canon DS. His printing, however, began and ended digitally, beginning with his Nash Editions Iris ink-jet prints using dyes and ending with his own Epson 7600 ink-jet printer using more permanent pigments. From such things, visual ideas are born.

From the onset, Robert Weingarten was enthralled by a single idea: to photographically picture a very special way of life. For him the Amish represented a commitment to honest simplicity, moral steadfastness, and an arcadian attachment to the earth, values so utterly absent from the contemporary urban world. Intuitively, or nearly so, he understood what had to be done and the intricacies of fulfilling his desires. His equipment and techniques may seem esoteric, totally up-to-date, and completely at odds with his subject, but he brought to that subject a vision that clearly apprehended what was to be seen, a subjectivity that sensed what was important to picture, and a talent that could emotionally articulate a pictorial response that was both honest and subtle, simple and complex. Today, as in other times of inordinate stress, such a combination of qualities seems imperative.

Weingarten's Amish photography is consumate documentary art in the strictest formal, aesthetic, and technical senses. Few see as well as he does, fewer have the design sense he has, and still fewer take printing to such a level of

perfection. Yet the old modernist sawhorses of formal, aesthetic, and technical matters of quality are not sufficient anymore in judging artistic quality. Other, newer, and some say equally important ideas concerning quality in the arts are emerging today. Among other ideas, the critic Thomas McEvilley noted a "sensed awareness of a particular location's resonances [and] the nesting of localities within localities to join one place to the rest of the world."[15]

Like many accomplished contemporary photographers of communities, geographies, and places, Weingarten has certainly felt the particular cultural resonances of the particular community he has photographed; he has paid attention to its nuances, respected it with humility, and has responsibly captured, to a degree, the ineffable. He has also located the various Amish communities within the broader context of America; he has demonstrated how this rather invisible set of settlements nestles within the larger whole of American society and beyond. His imagery also reminds us that there are moral lessons to be learned from the Amish.

In the end, we have far more words in our vocabularies for differences than we have for similarities. Certainly, the Amish are not us; they are different, they are an "Other," and they choose to remain that way. But just as there are plenty of details separating them from the plural us, there are equally plenty of aspects to their lives that are compellingly similar to ours. Weingarten has well documented what he refers to as "Another America"; he has also testified to its essential and indominable human spirit through his remarkable photographs.

Robert A. Sobieszek

Head Curator, Department of Photography,

Los Angeles County Museum of Art

1 Robert Weingarten, in conversation with the author, July 17, 2002.
2 Weingarten, in conversation with the author, April 22, 2004.
3 *Ibid.*
4 John Grierson, *Grierson on Documentary*, ed. Forsyth Hardy (London: Faber,1966), 136; quoted in John Stott, *Documentary Expression and Thirties America* (Chicago: University of Chicago Press, 1986), 10.
5 Douglas Eklund, "Exile's Return: The Early Work, 1928–34," in Maria Morris Hambourg, et al., *Walker Evans*, exh. cat. (New York: The Metropolitan Museum of Art, 2000), 52, n. 68.
6 General background on the Amish has been culled from various websites on the internet, such as www.800padutch.com/amish.shtml.
7 Bishop Mose Byler, quoted in Lisa W. Foderaro, "No Wiggle Room in This Window War," the *New York Times* (November 15, 2003), A12. For the telephone debates, see Diane Zimmerman Umble, "Sinful Network or Divine Service: Competing Meanings of the Telephone in Amish Country," in *New Media, 1740–1915*, ed. Lisa Gitelman and Geoffrey B. Pingree (Cambridge: The MIT Press, 2003), 139-56.
8 See Brad Igou (ed.), "The Amish & Photographs," *Amish Country News* (December 6, 2001), available online: www.amishnews.com/amisharticles/amishand%20photos.htm.
9 Donald B. Kraybill, *The Riddle of Amish Culture* (Baltimore: Johns Hopkins University Press, 1989); cited in *ibid.*
10 Roland Barthes, *Camera Lucida: Reflections on Photography*, trans. Richard Howard (New York: Hill and Wang, 1981), 28, 34.
11 Grierson, loc cit; quoted in Stott, loc cit.
12 Peter Henry Emerson, *Naturalistic Photography for Students of the Art* (London: Sampson Low, Marston, Searle & Rivington, 1889), 251.
13 Henry Peach Robinson, *Picture-Making by Photography* (London: Hazell, Watson, & Viney, 1897), 80.
14 William Carlos Williams, *Patterson* I (1946); reprinted in *Paterson*, ed. Christopher MacGowan (New York: New Directions, 1992), 6.
15 Thomas McEvilley, *Art & Otherness: Crisis in Cultural Identity* (Kingston, NY: McPherson and Company, 1992), 13.

Plates

Amish 17, Lancaster County, PA 2001

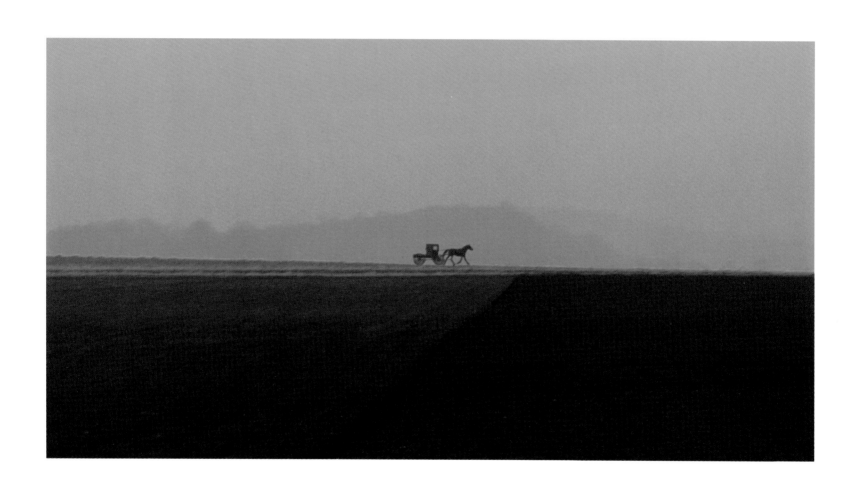

Amish 22, Lancaster County, PA, 2001

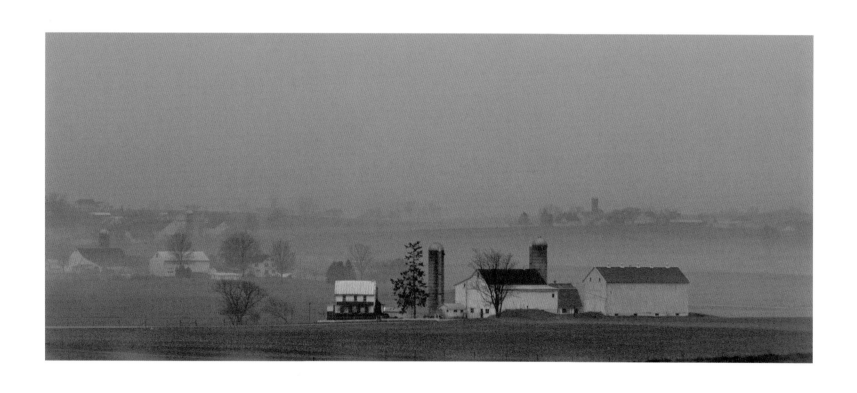

Amish 25, Lancaster County, PA, 2001

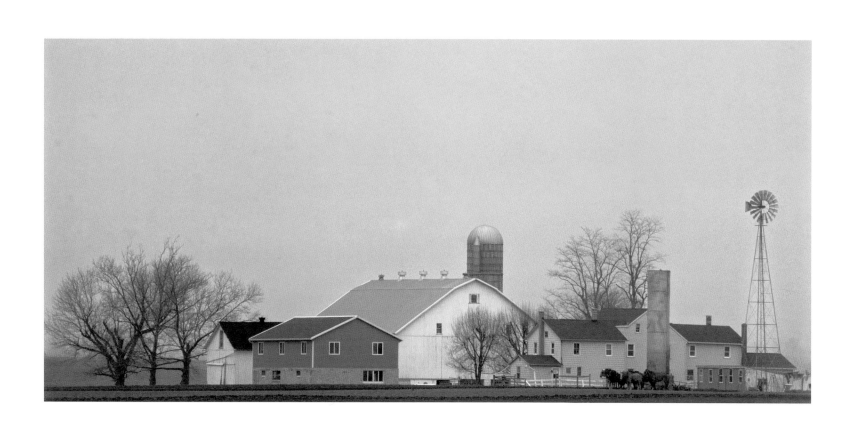

Amish 80, Monroe County, WI, 2003

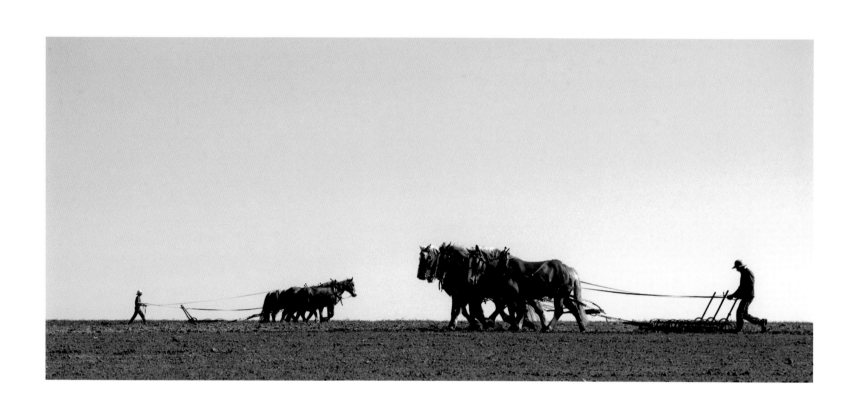

Amish 21, Lancaster County, PA, 2001

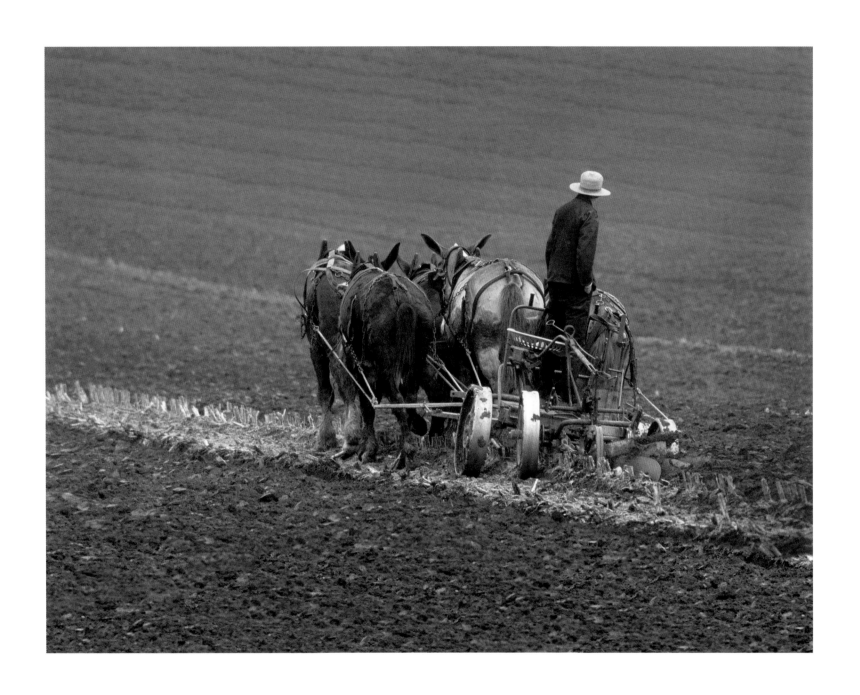

Amish 87, Bedford County, TN 2003

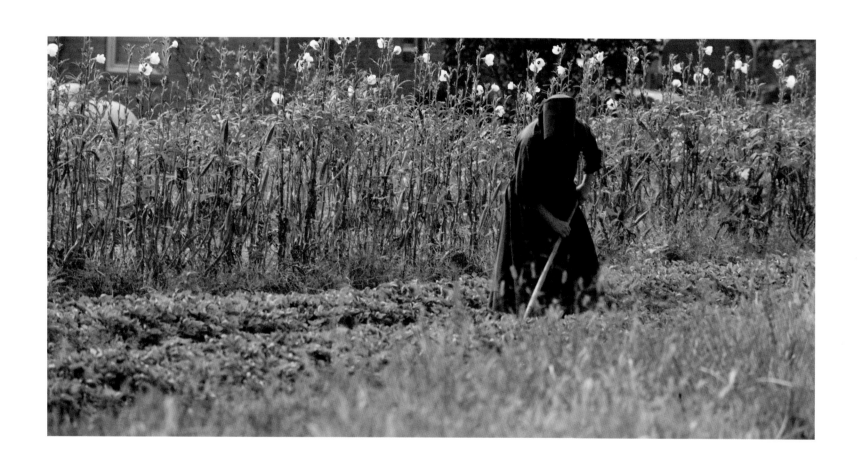

Amish 93, Bedford County, TN 2003

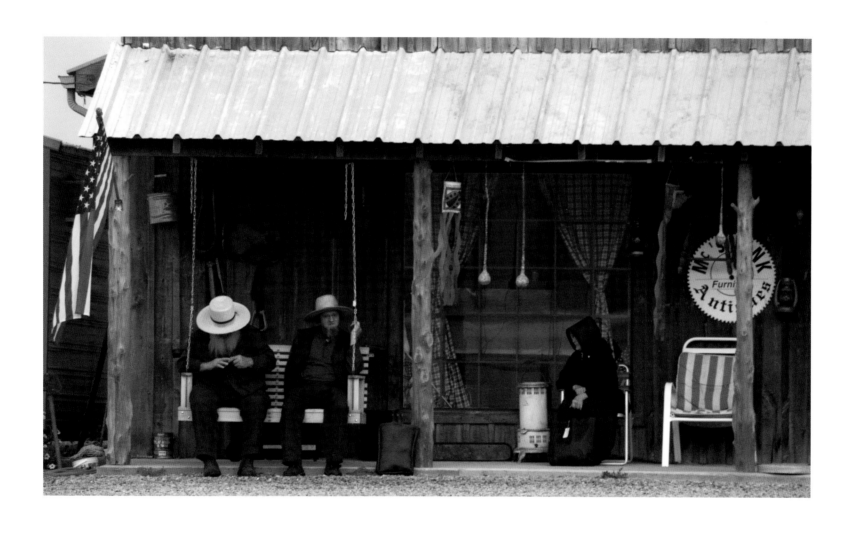

Amish 34, Holmes County, OH, 2002

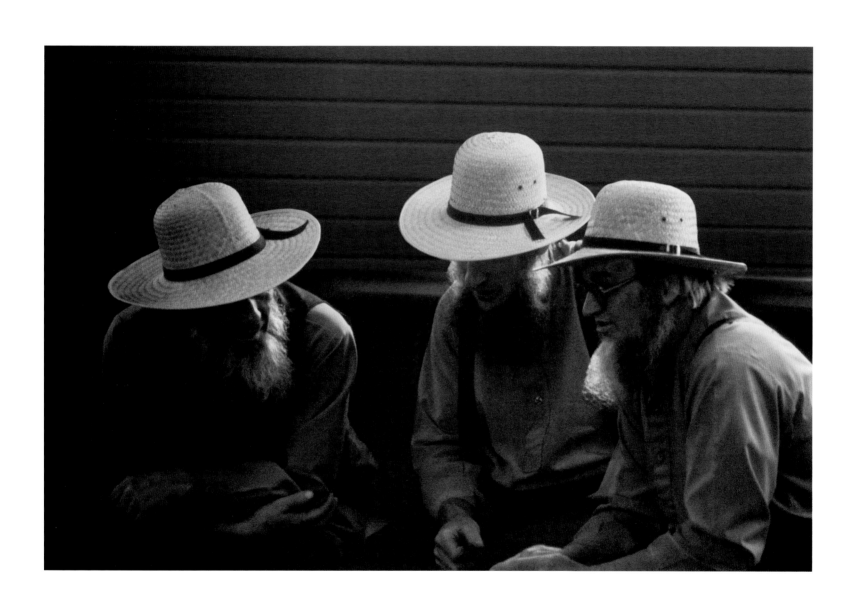

Amish 28, Lancaster County, PA, 2001

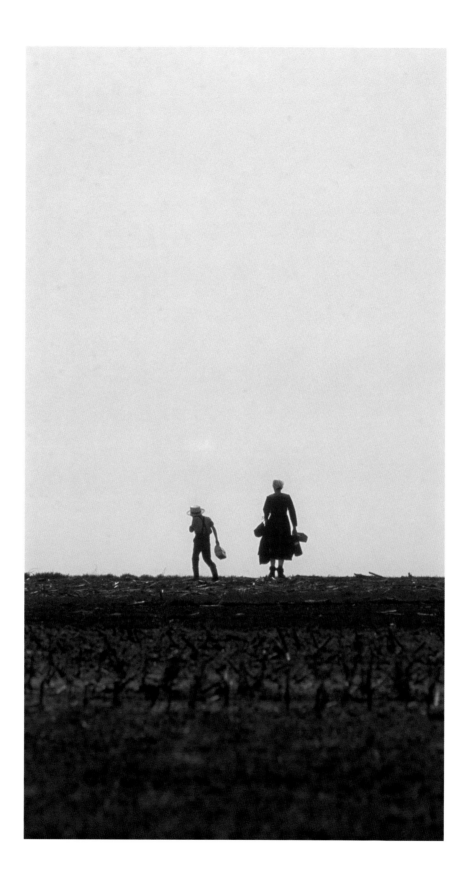

Amish 33, Holmes County, OH, 2002

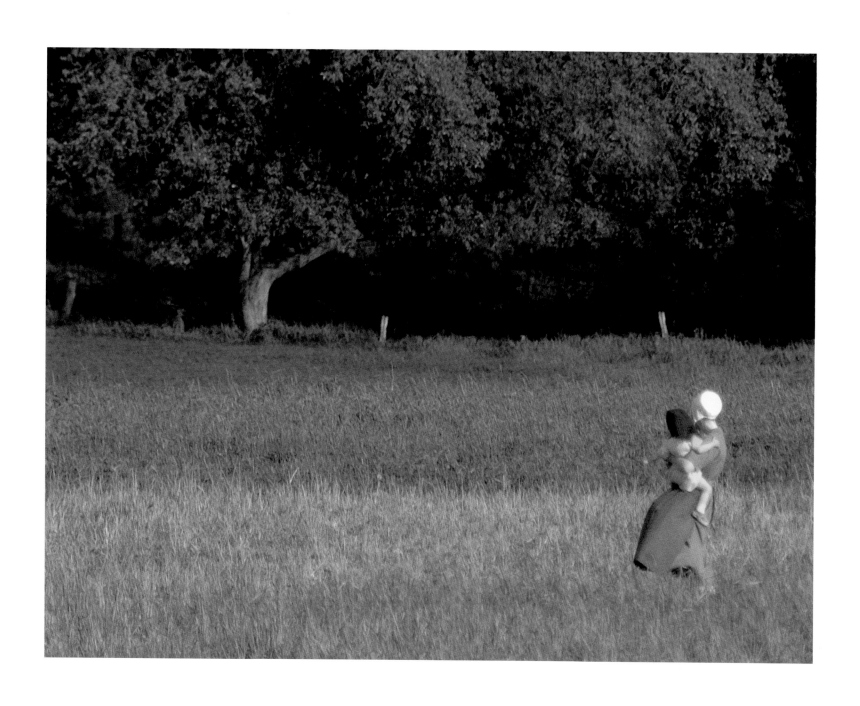

Amish 35, Holmes County, OH, 2002

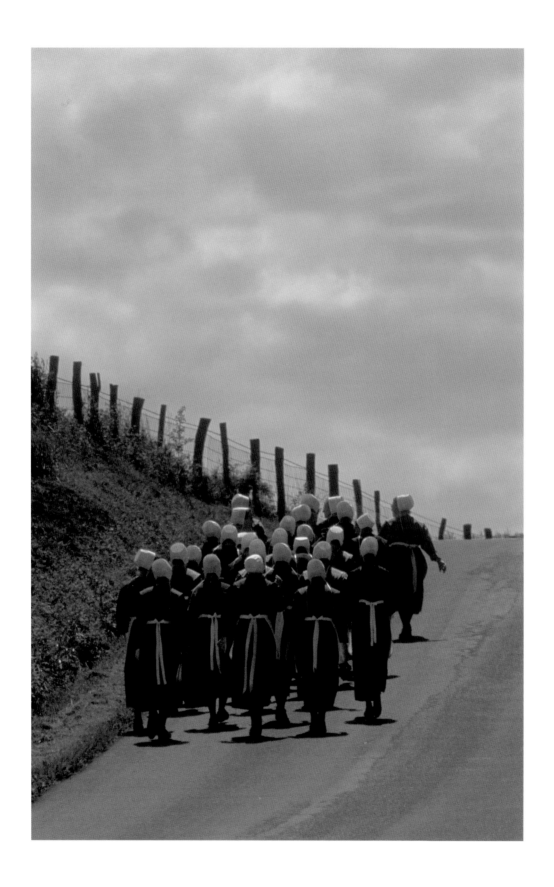

Amish 36, Holmes County, OH, 2002

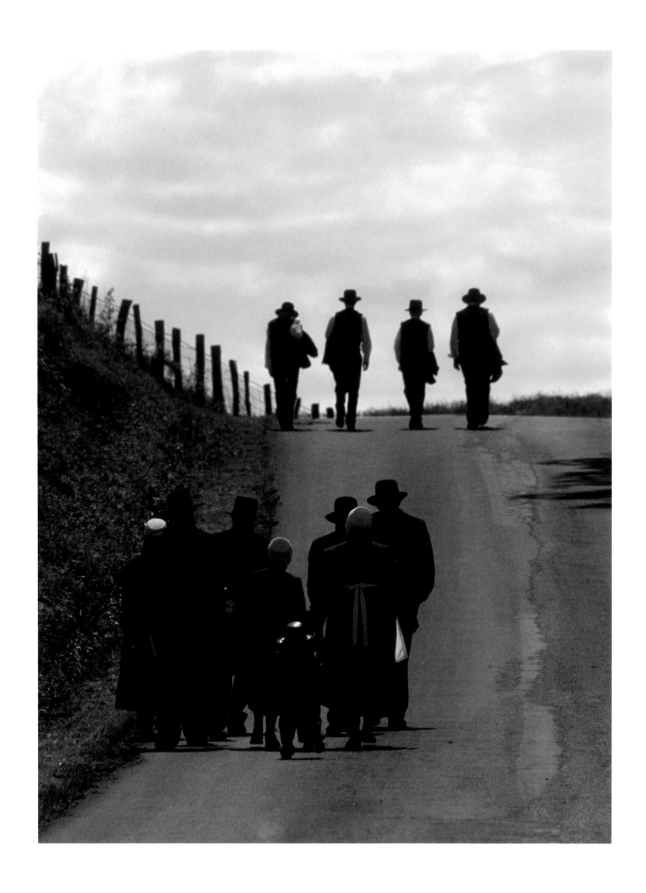

Amish 59, Elkhart County, IN, 2002

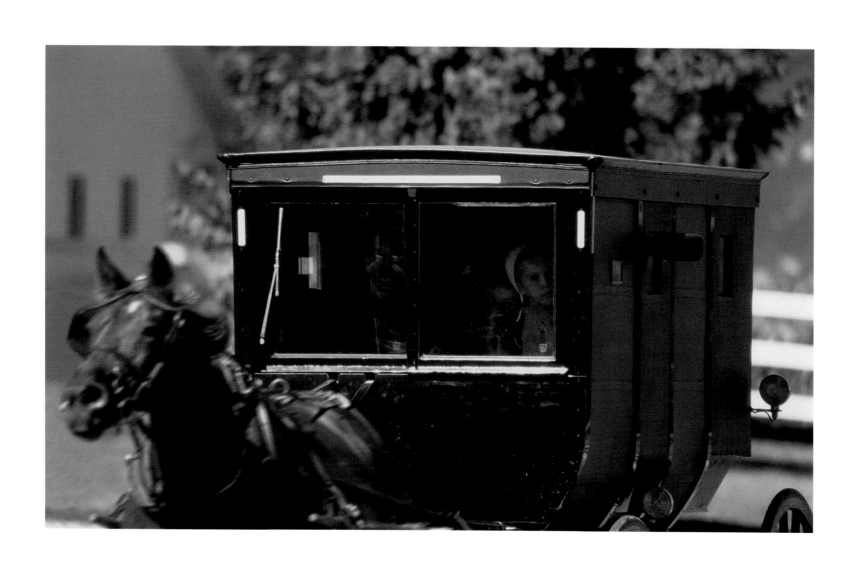

Amish 86, Monroe County, WI, 2003

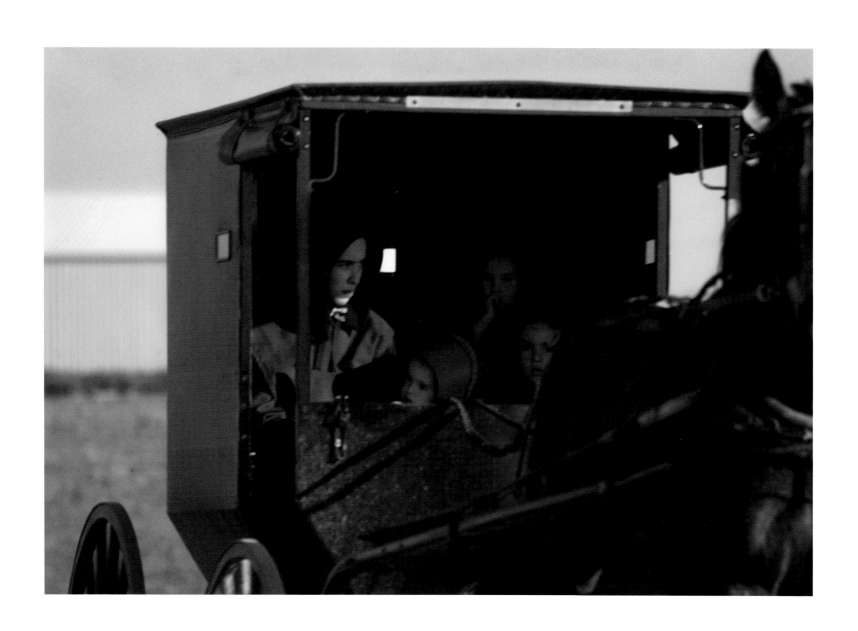

Amish 68, Elkhart County, IN, 2002

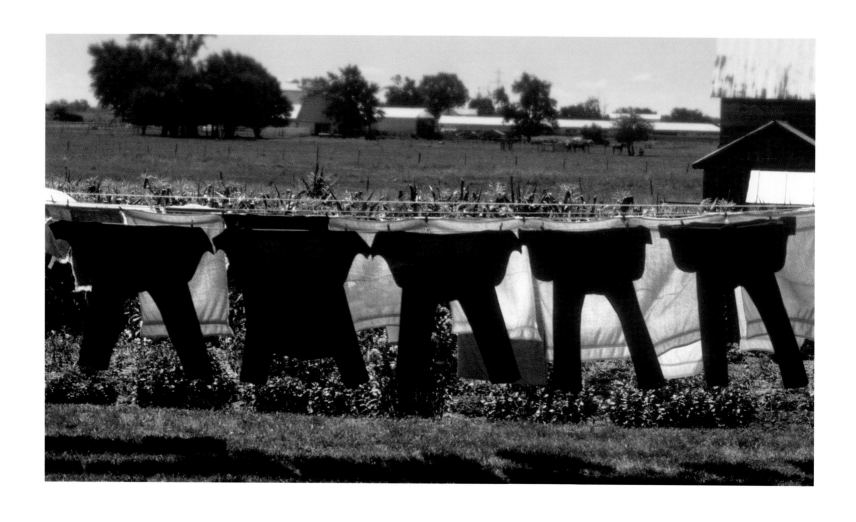

Amish 12, Lancaster County, PA 2001

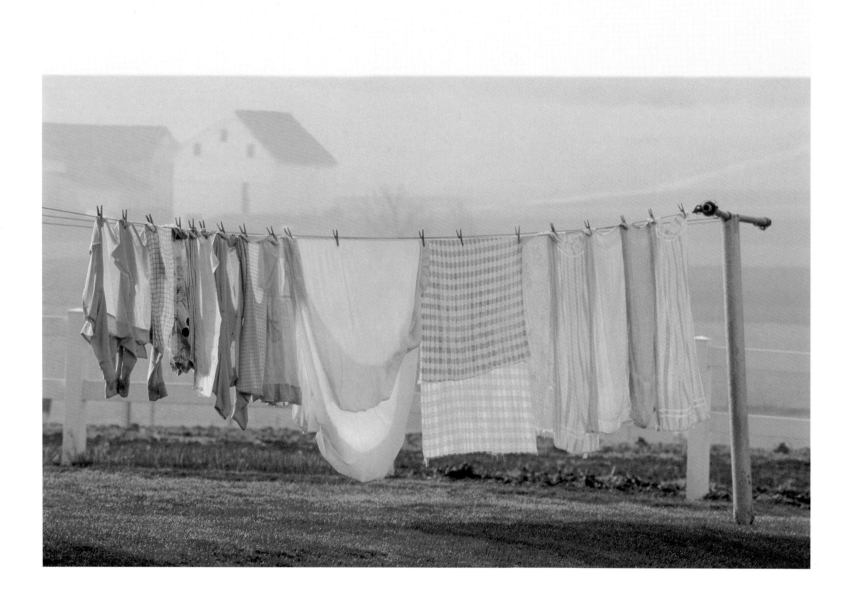

Amish 48, Holmes County, OH, 2002

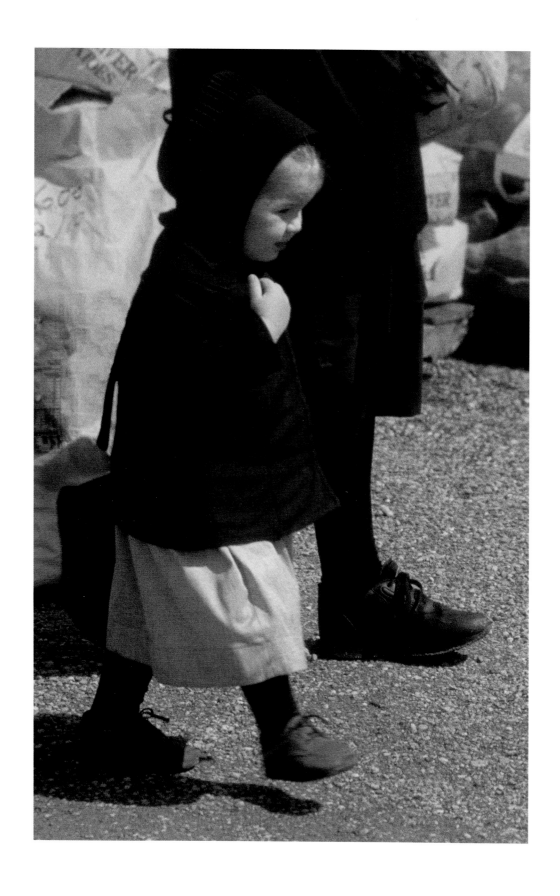

Amish 79, Lancaster County, PA, 2003

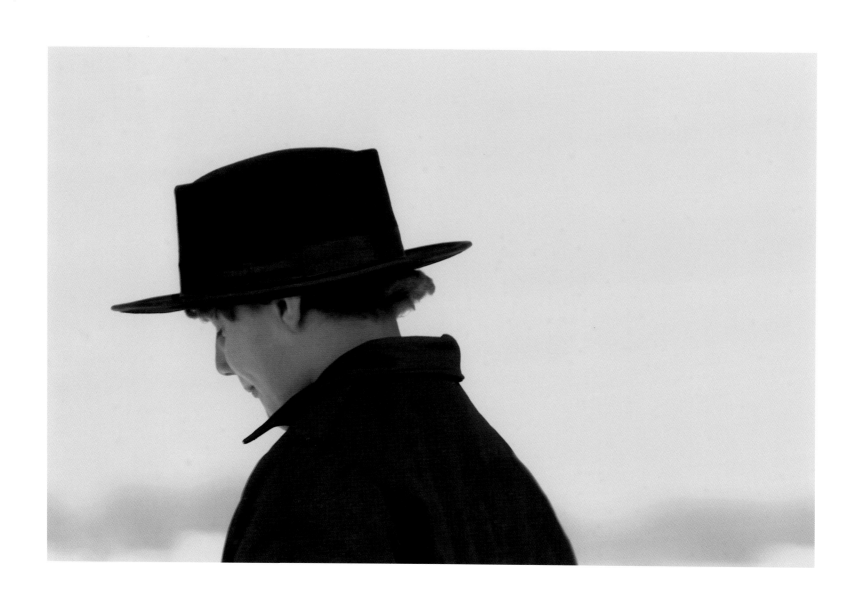

Amish 73, Lancaster County, PA, 2003

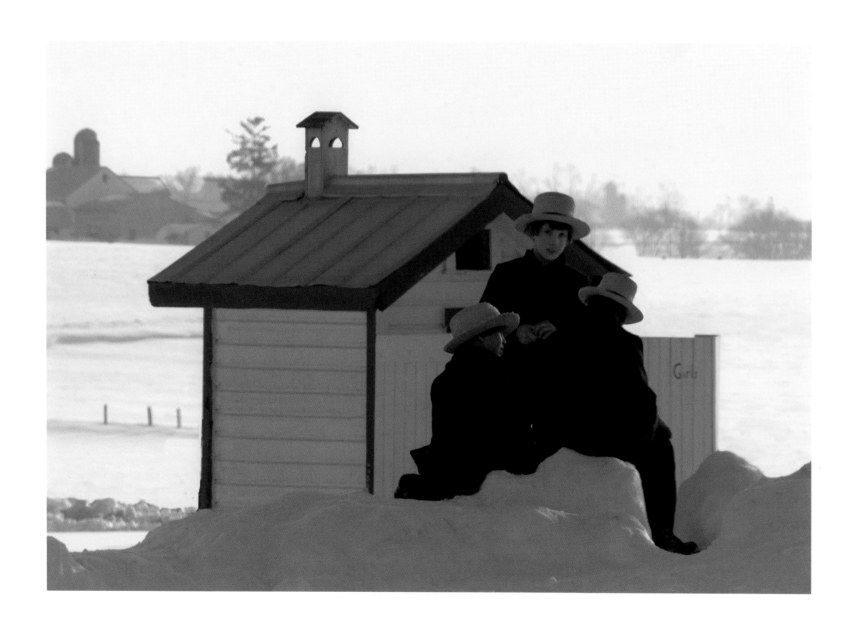

Amish 72, Lancaster County, PA, 2003

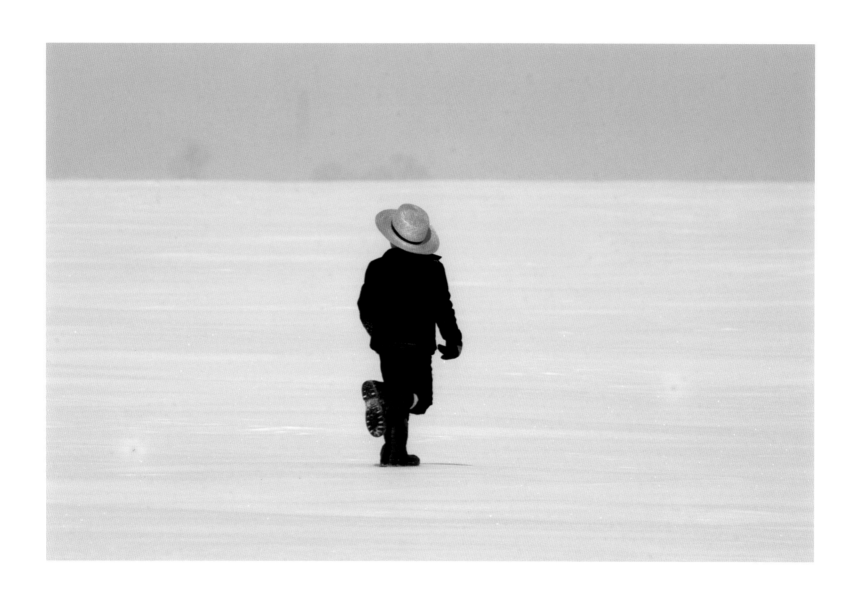

Amish 10, Lancaster County, PA, 2001

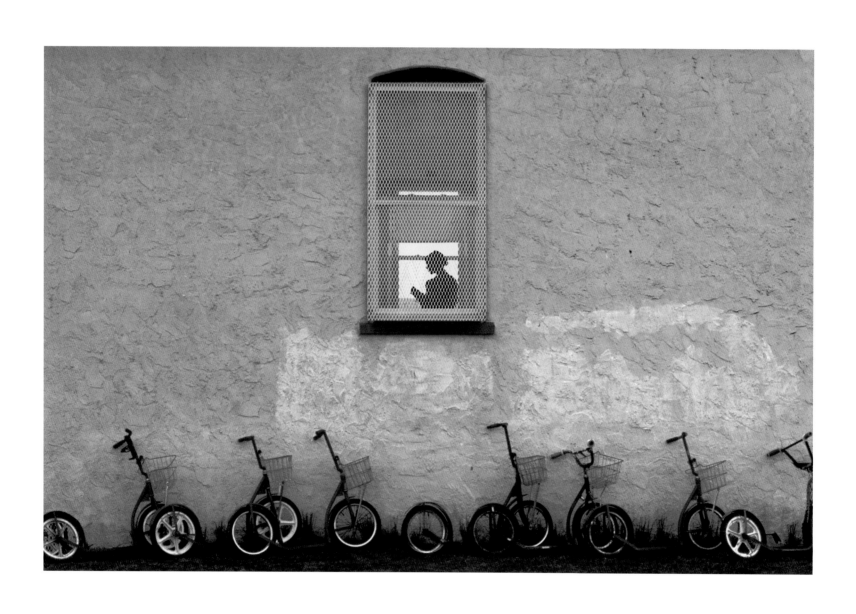

Amish 13, Lancaster County, PA, 2001

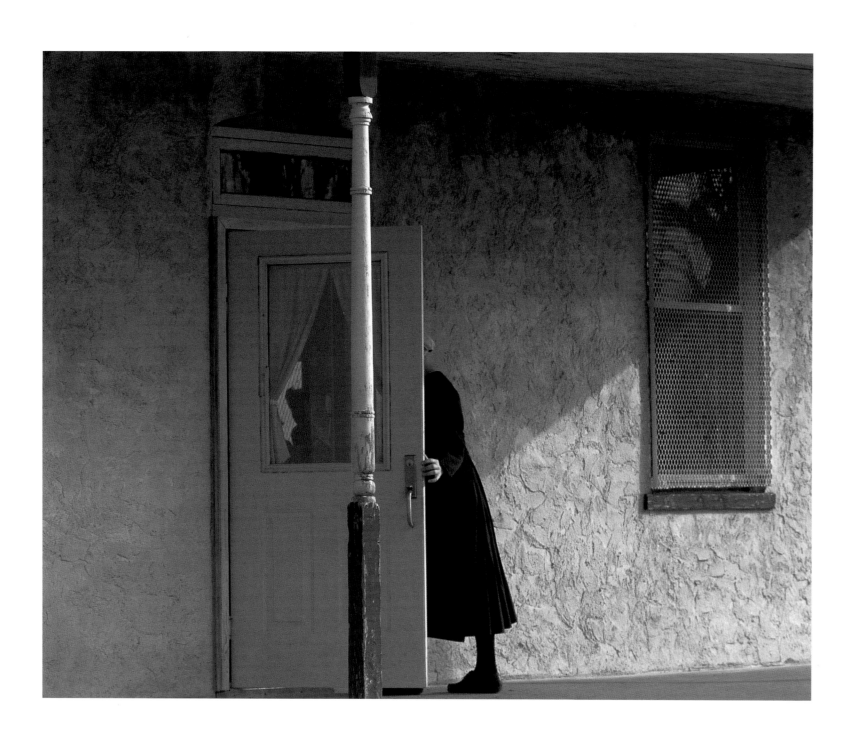

Amish 43, Holmes County, OH, 2002

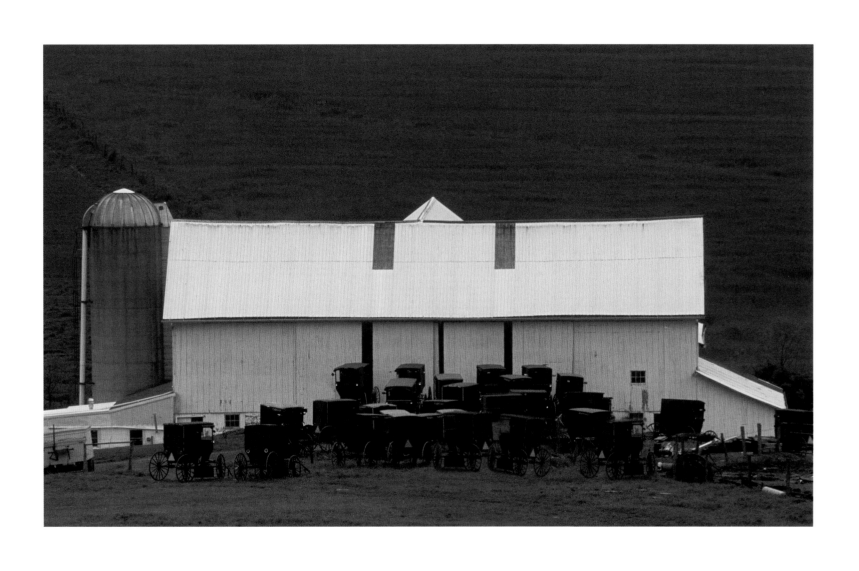

Amish 94, Washington County, IA, 2004

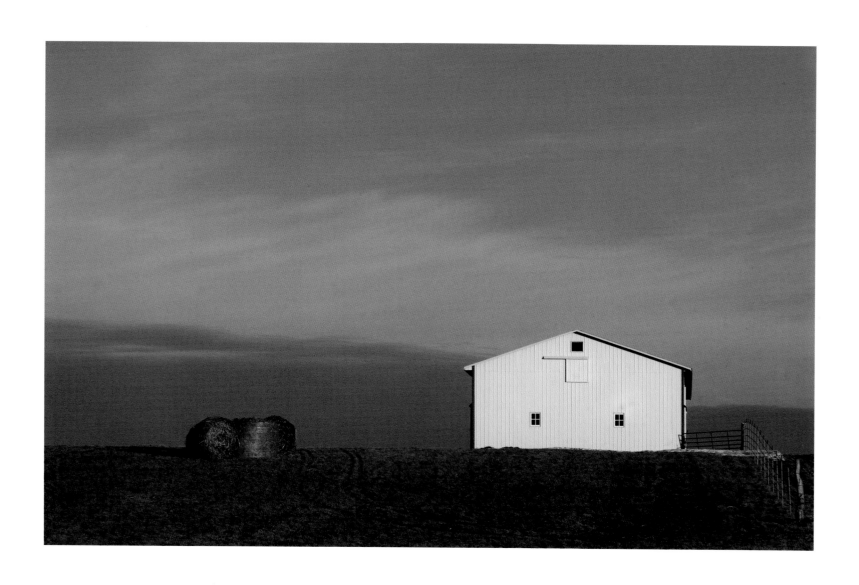

Amish 4, Lancaster County, PA, 2001

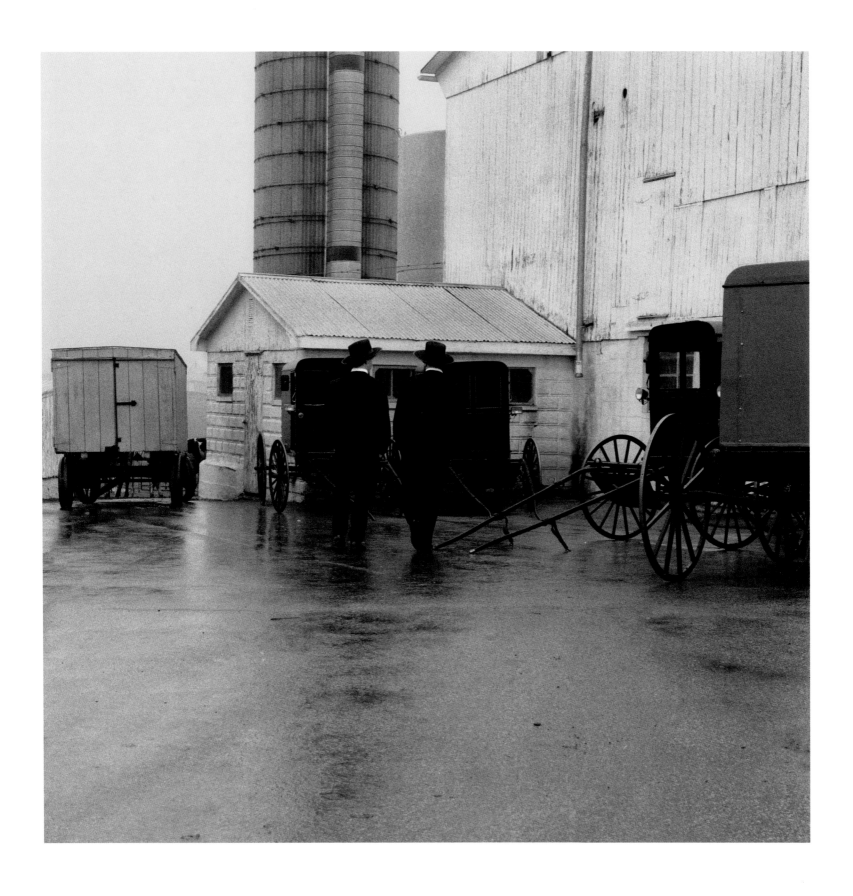

Amish 3, Lancaster County, PA, 2001

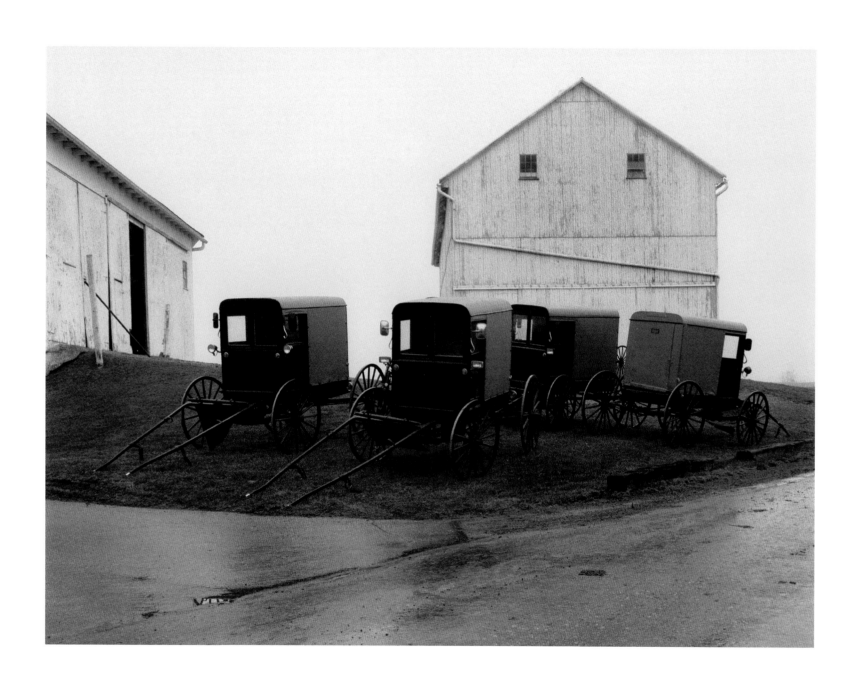

Amish 23, Lancaster County, PA, 2001

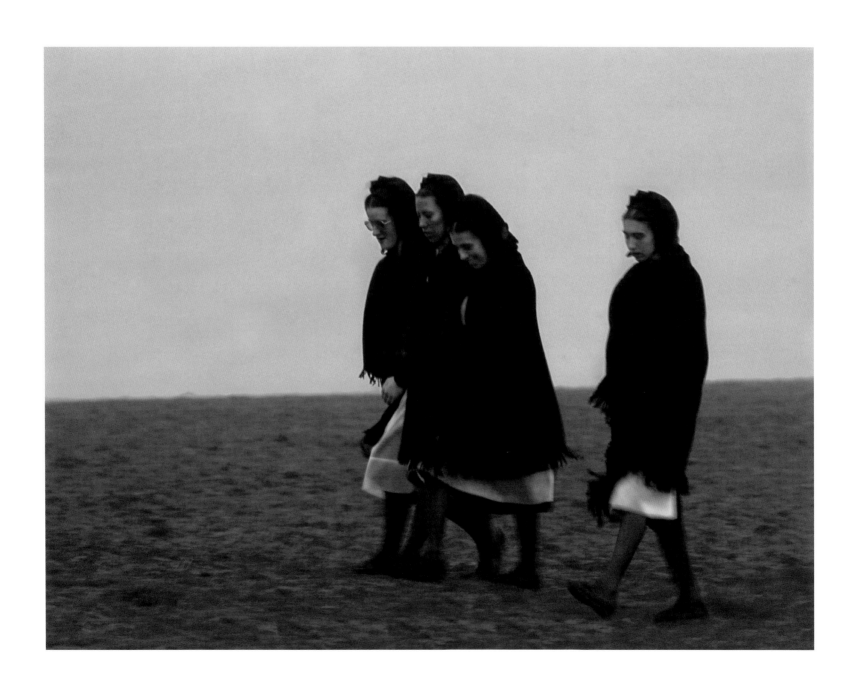

Amish 2, Lancaster County, PA, 2001

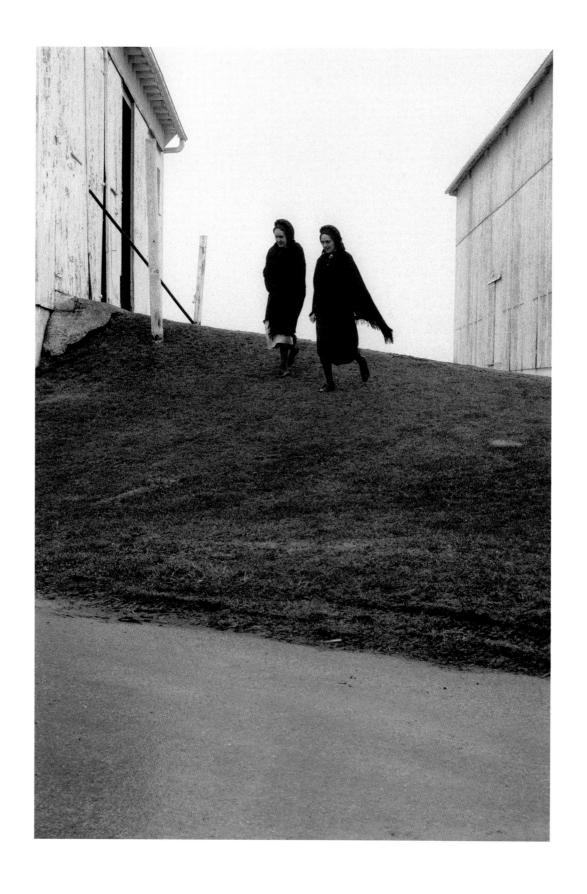

Amish 66, Elkhart County, IN, 2002

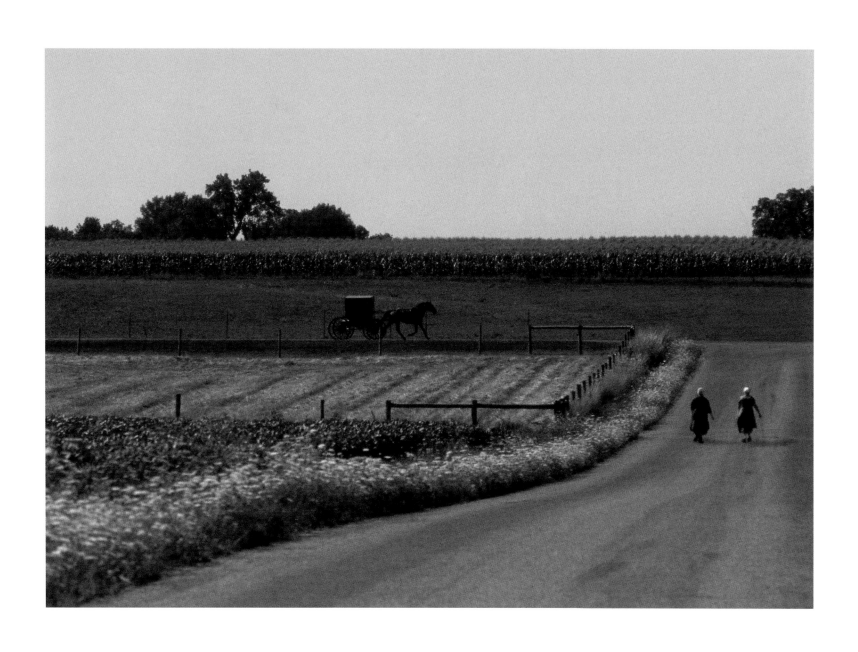

Amish 16, Lancaster County, PA, 2001

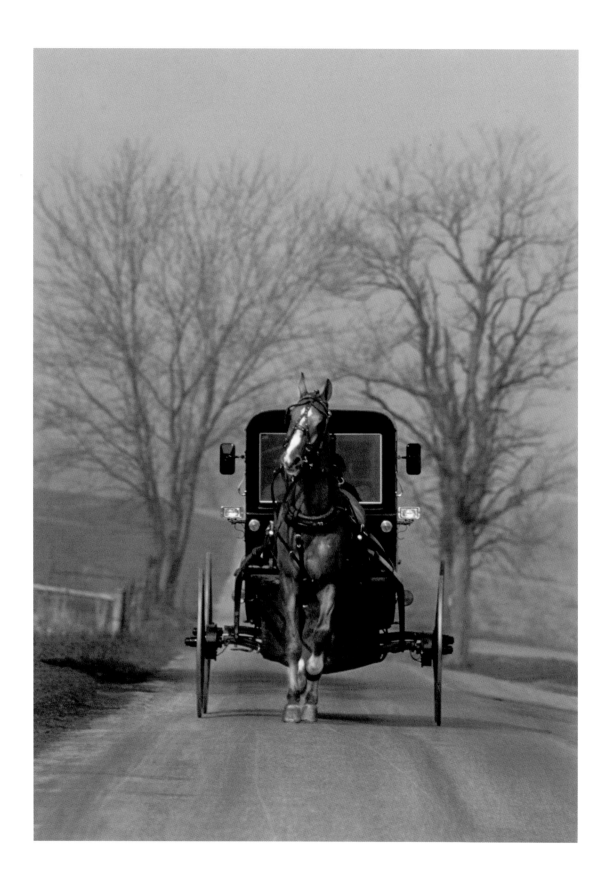

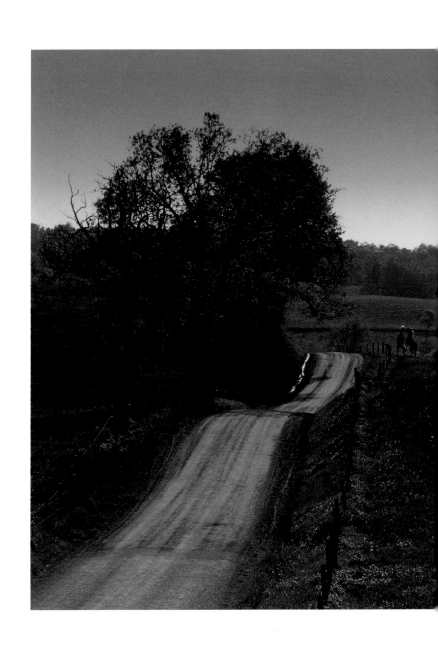

Amish 50, 5:23p.m., Holmes County, OH, 2002

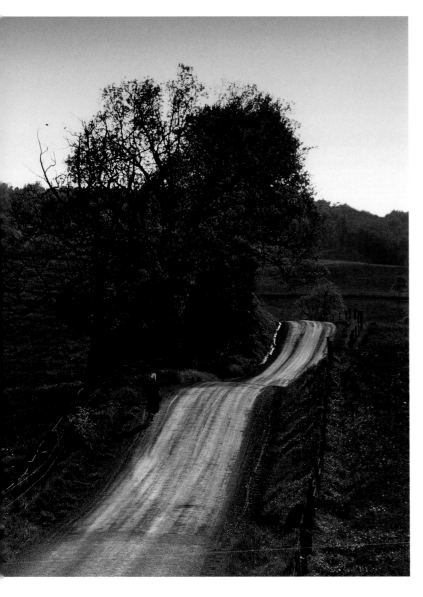

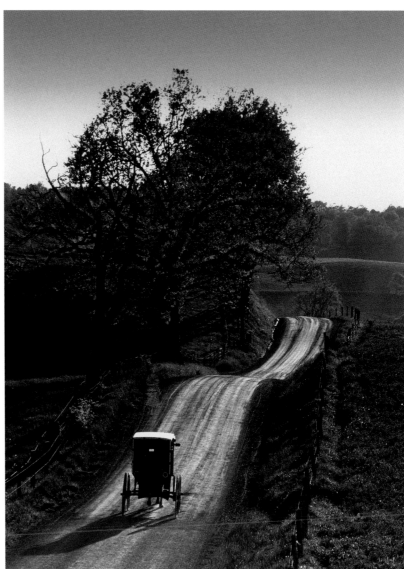

Amish 51, 6:14p.m., Holmes County, OH, 2002 Amish 52, 7:40p.m., Holmes County, OH, 2002

Amish 11, Lancaster County, PA, 2001

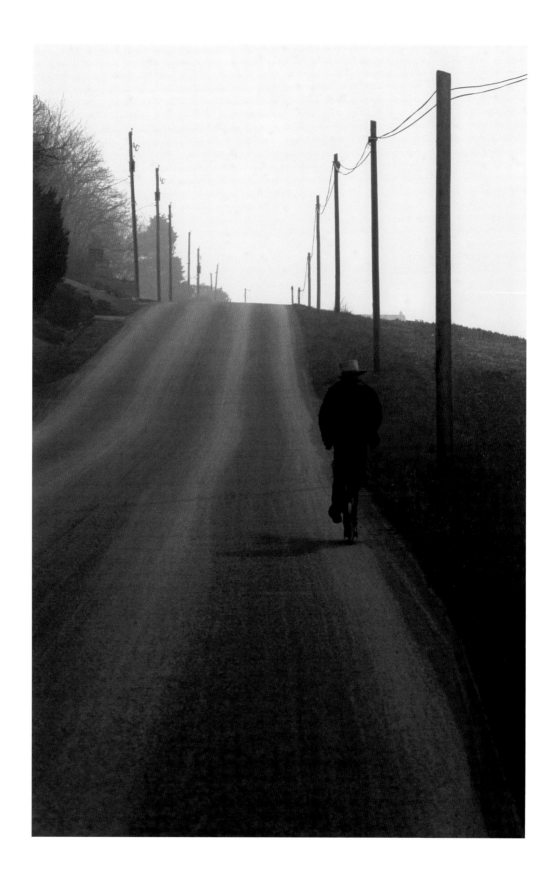

Amish 24, Lancaster County, PA 2001

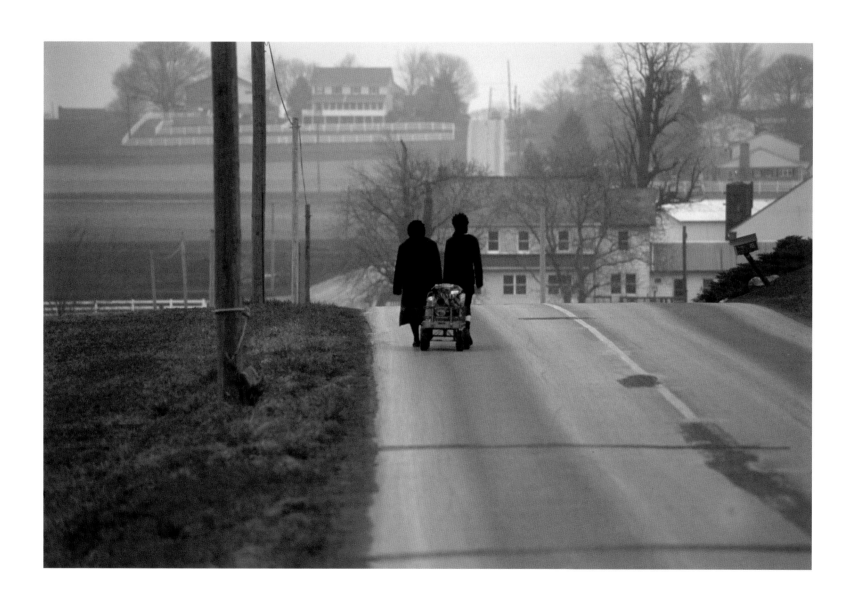

Amish 76, Lancaster County, PA, 2003

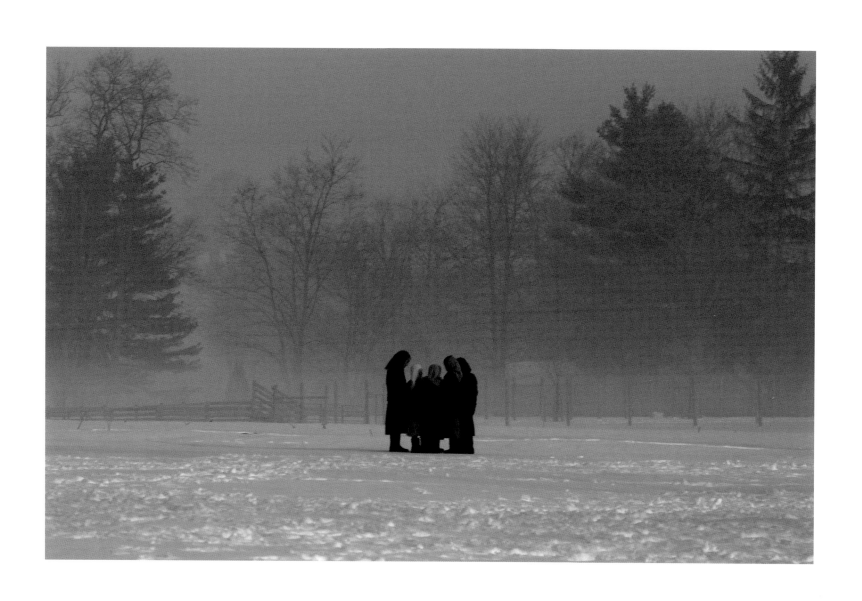

Amish 70, Lancaster County, PA, 2002

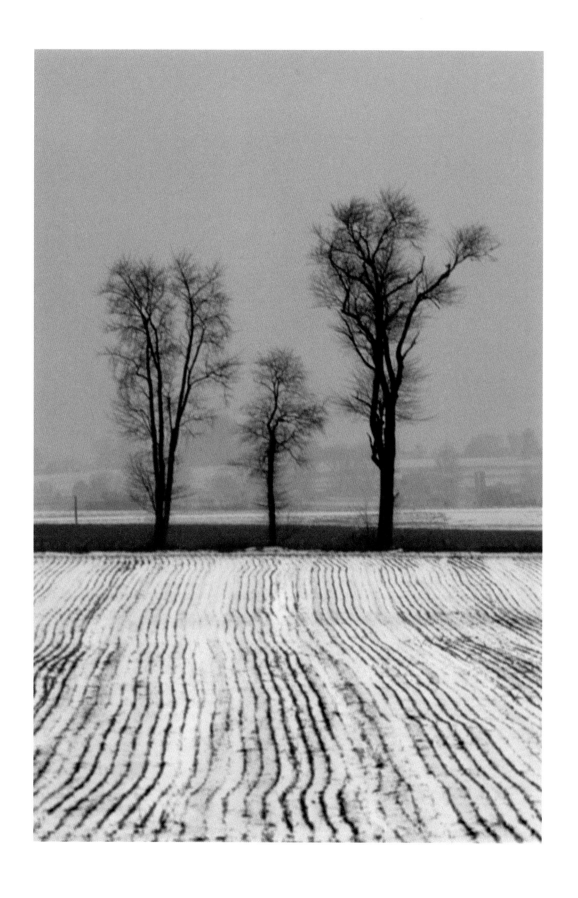

Amish 19, Lancaster County, PA, 2001

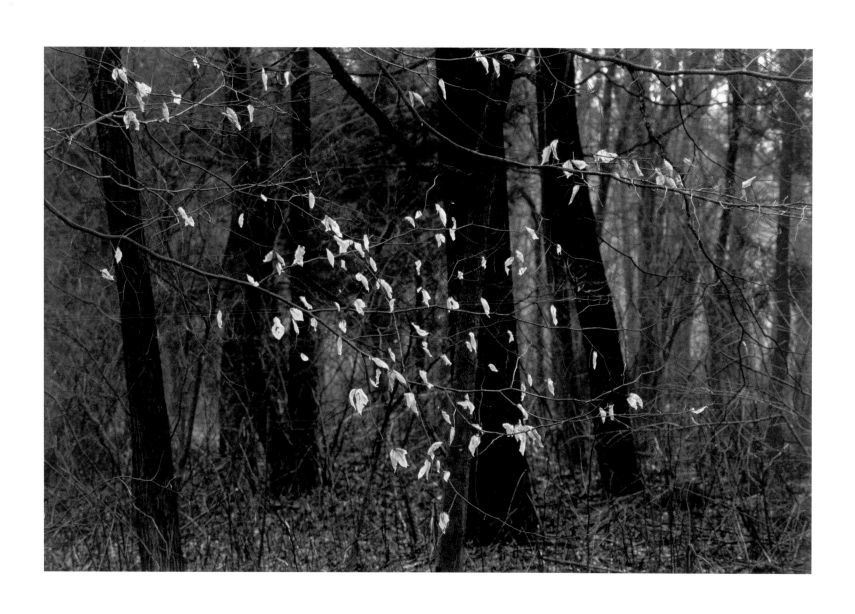

Amish 32, Holmes County, OH 2002

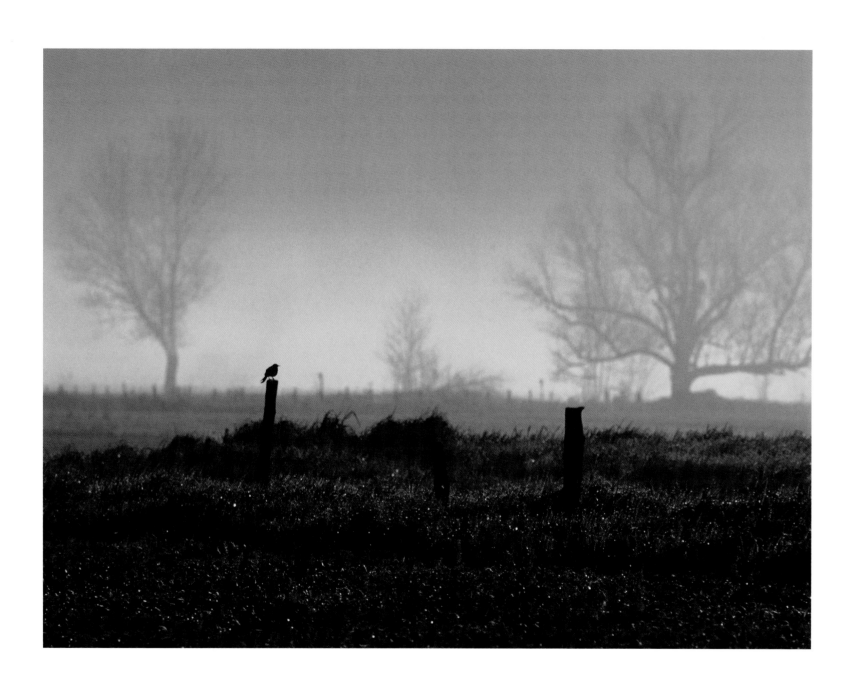

Amish 54, Elkhart County, IN, 2002

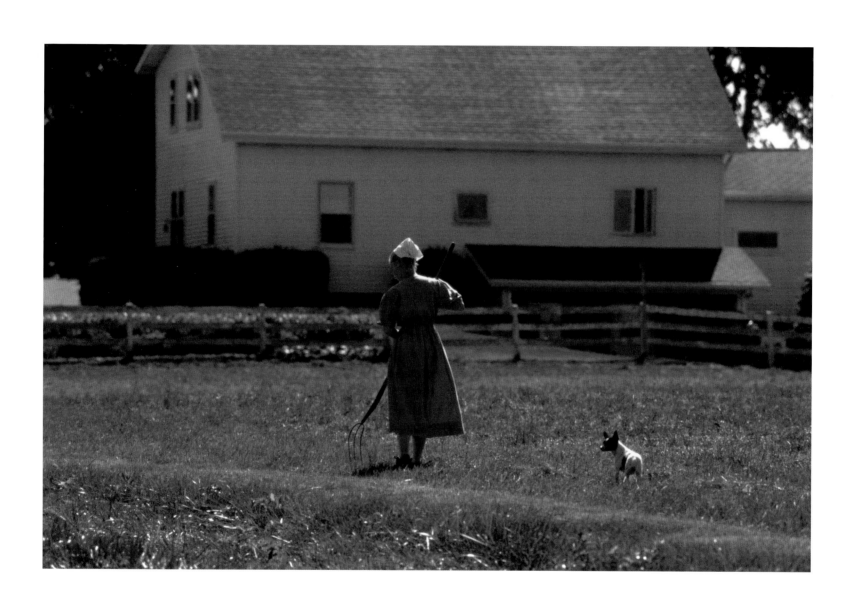

Amish 53, Goshen County, IN, 2002

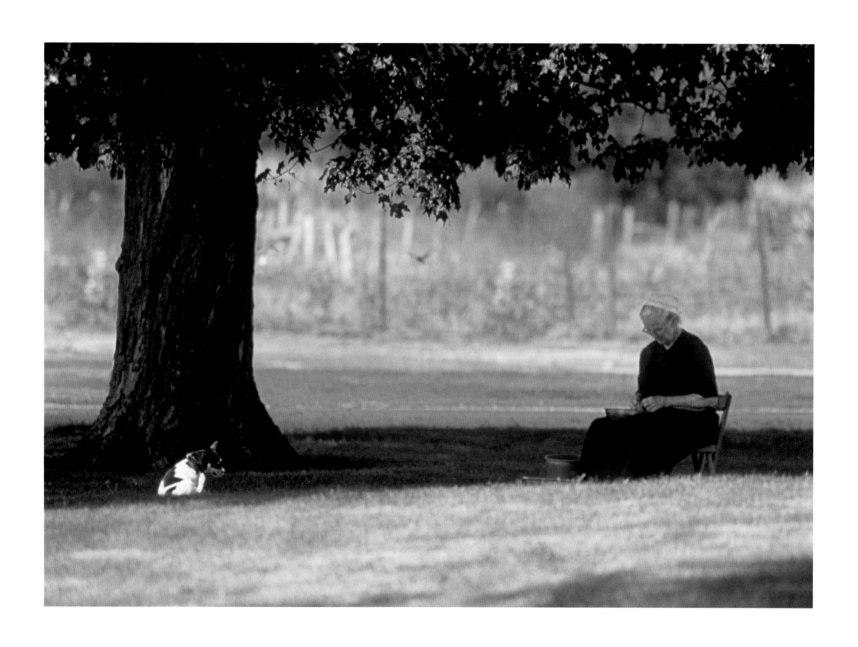

Amish 60, Elkhart County, IN, 2002

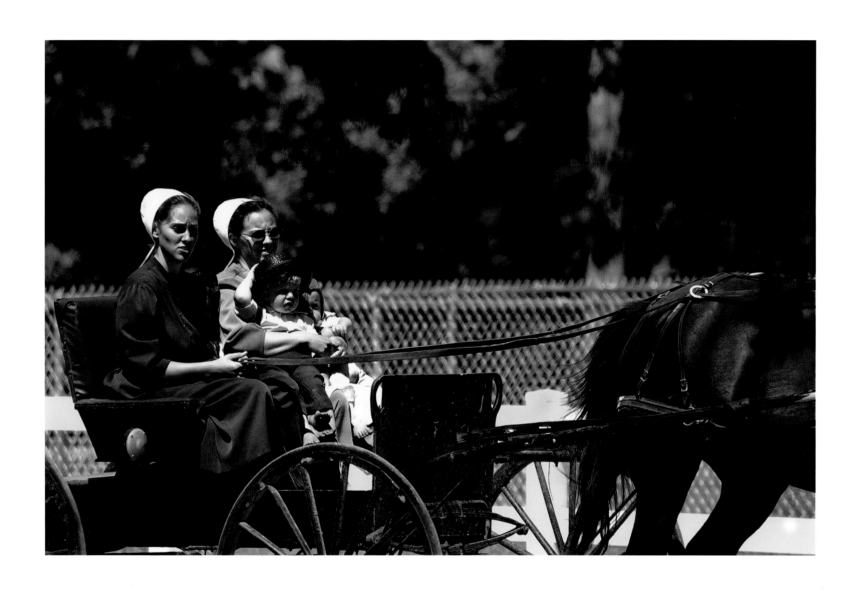

Amish 63, Elkhart County, IN, 2002

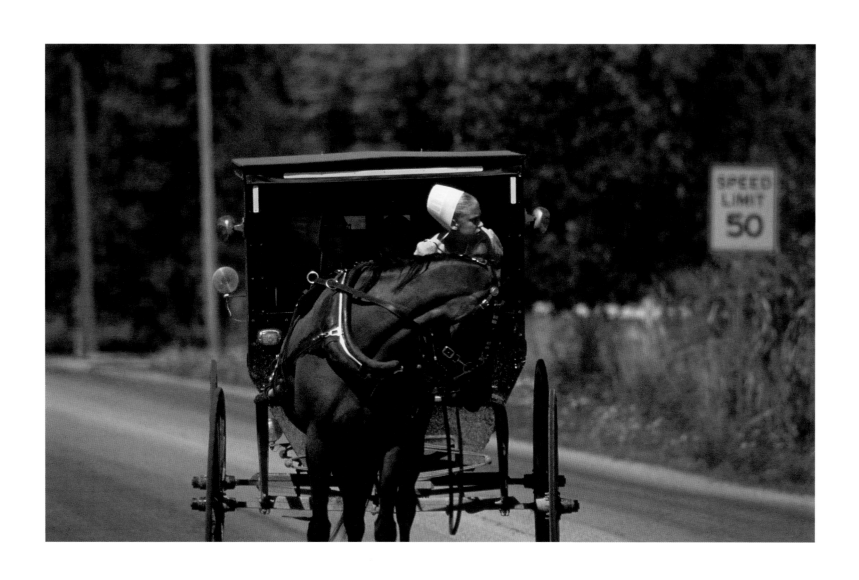

Amish 62, Elkhart County, IN 2002

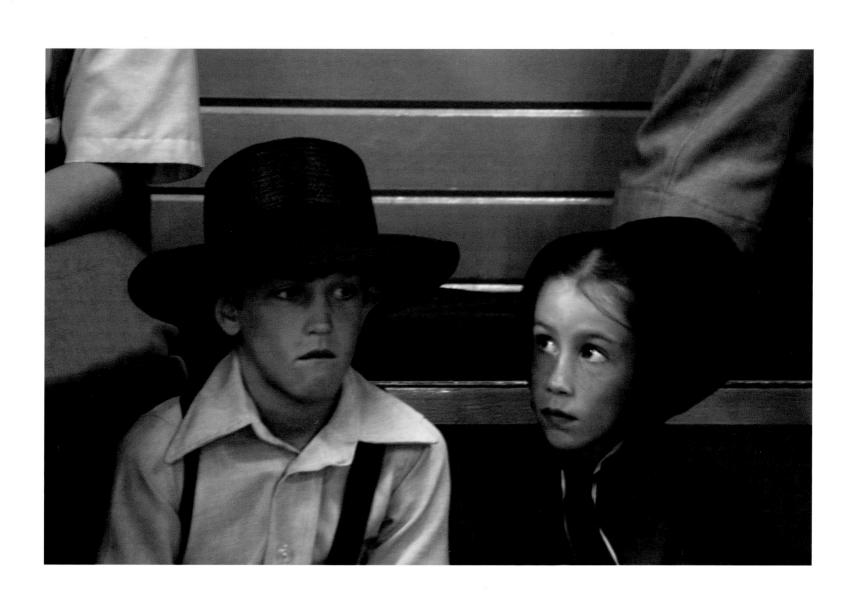

Amish 39, Holmes County, OH, 2002

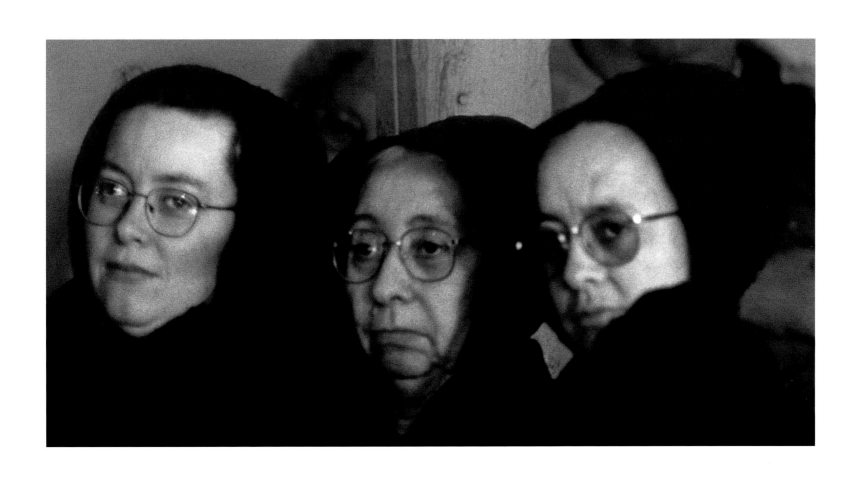

Amish 65, Elkhart County, IN, 2002

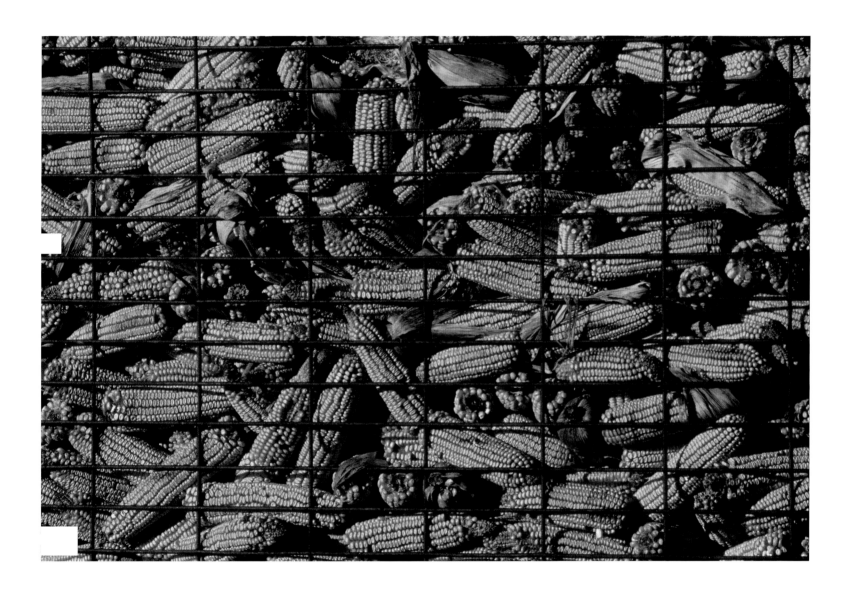

Amish 42, Holmes County, OH, 2002

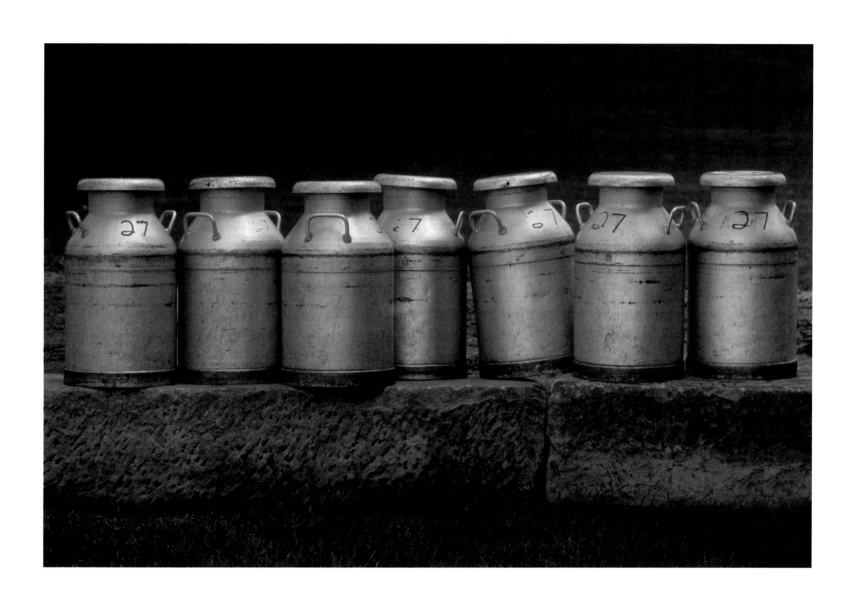

Amish 71, Lancaster County, PA, 2001

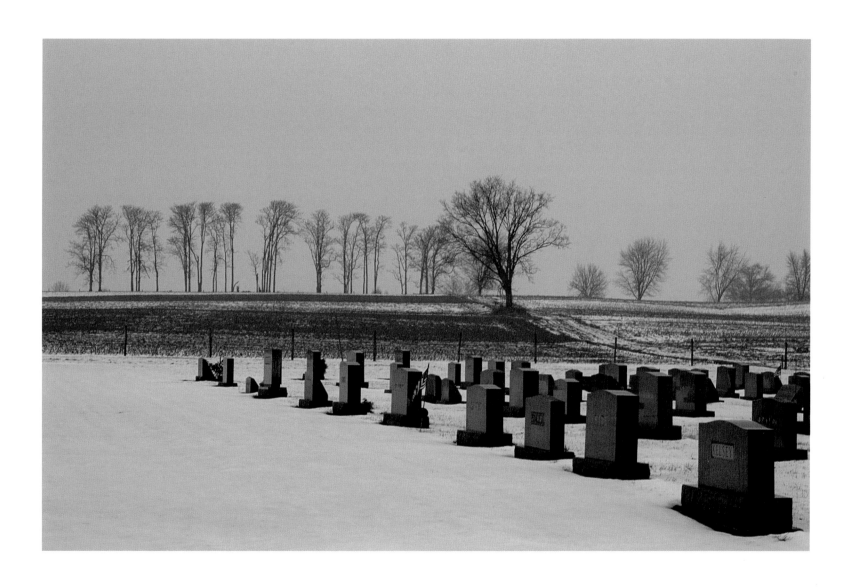

Amish 69, Lancaster County, PA, 2001

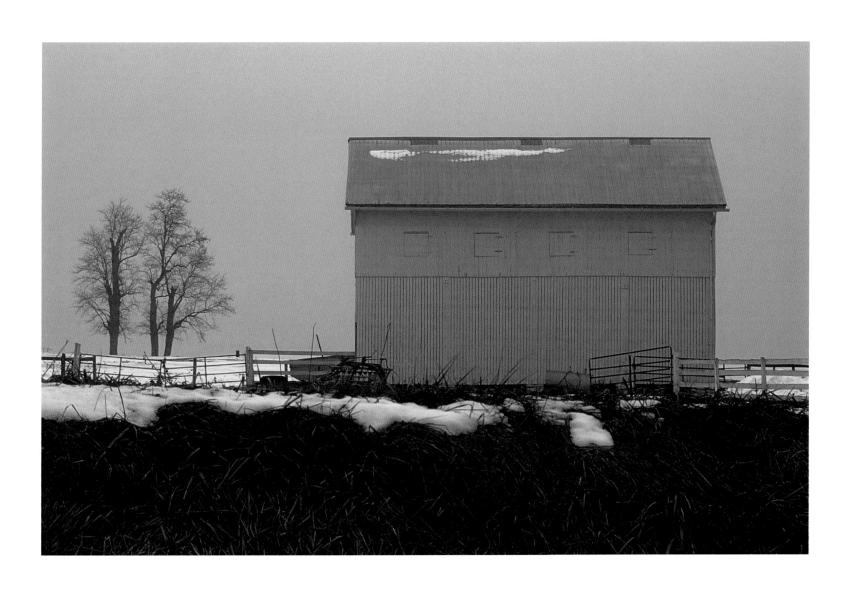

Amish 44, Holmes County, OH, 2002

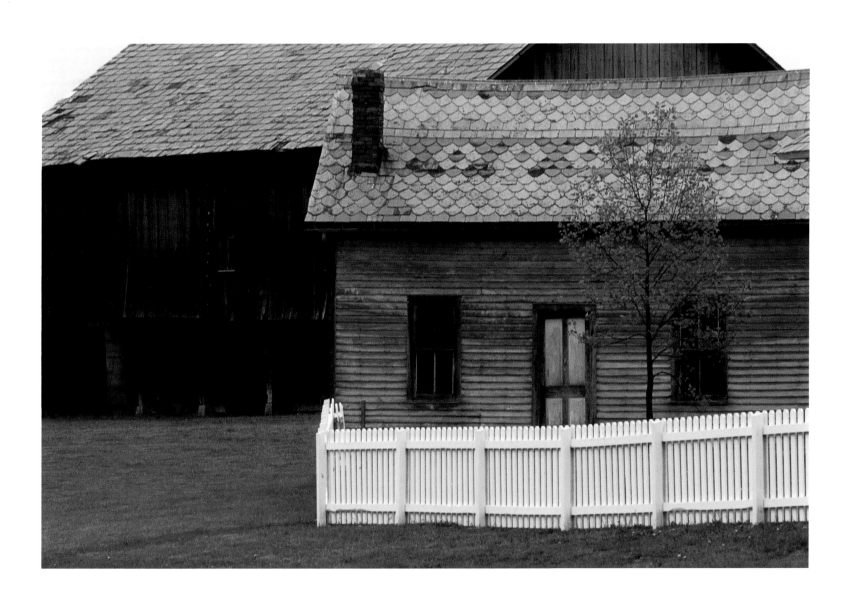

Amish 45, Holmes County, OH 2002

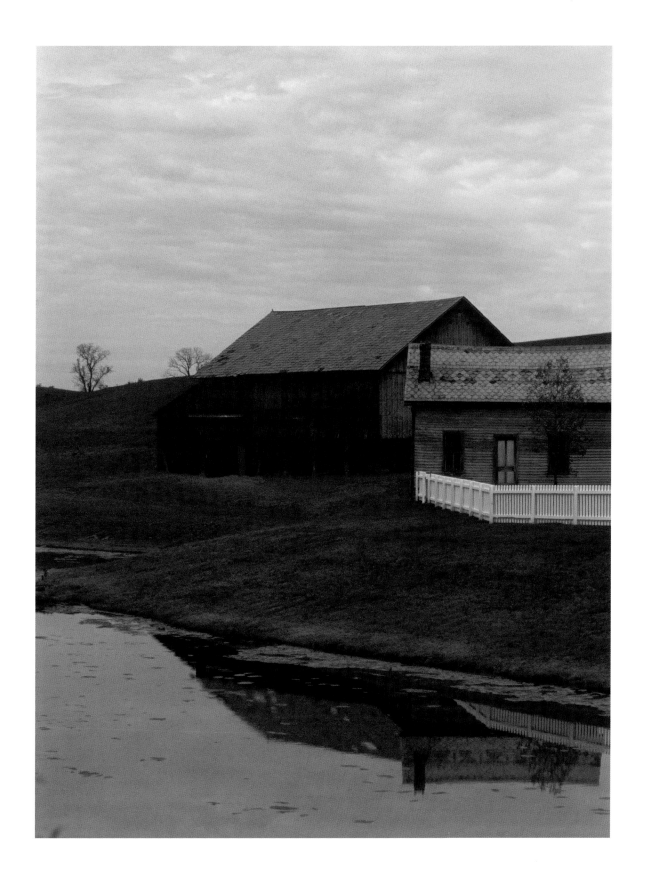

Amish 14, Lancaster County, PA, 2001

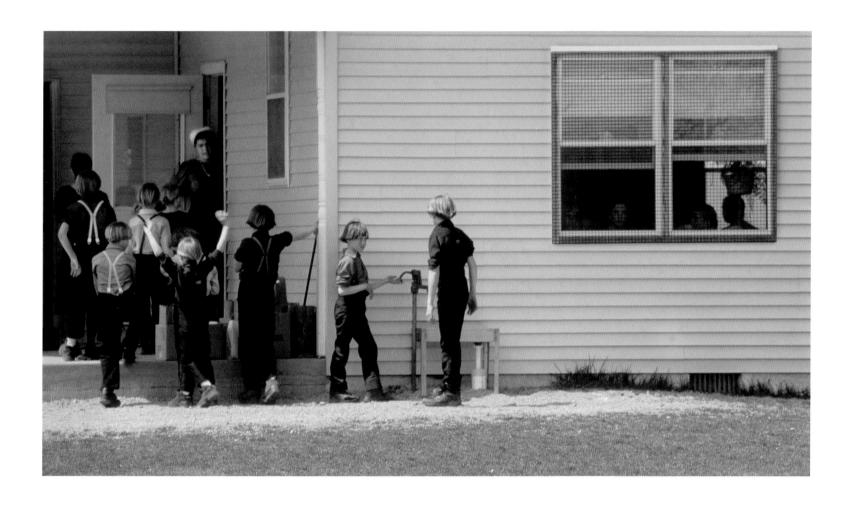

Amish 29, Lancaster County, PA, 2001

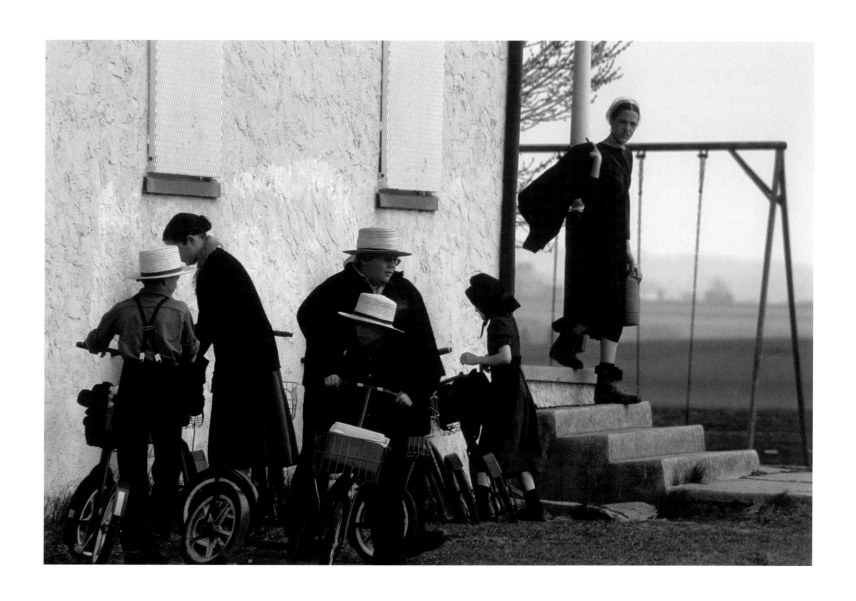

Amish 95, Washington County, IA, 2004

Amish 96, Washington County, IA, 2004

Amish 55, Elkhart County, IN 2002

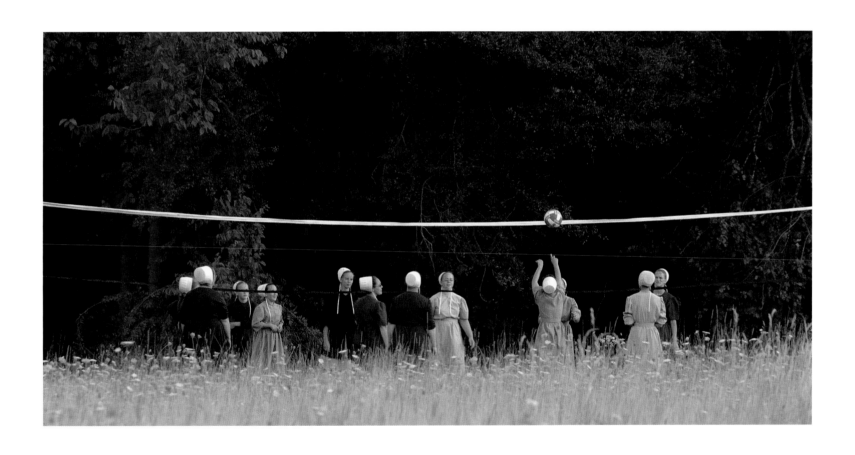

Amish 56, Elkhart County, IN, 2002

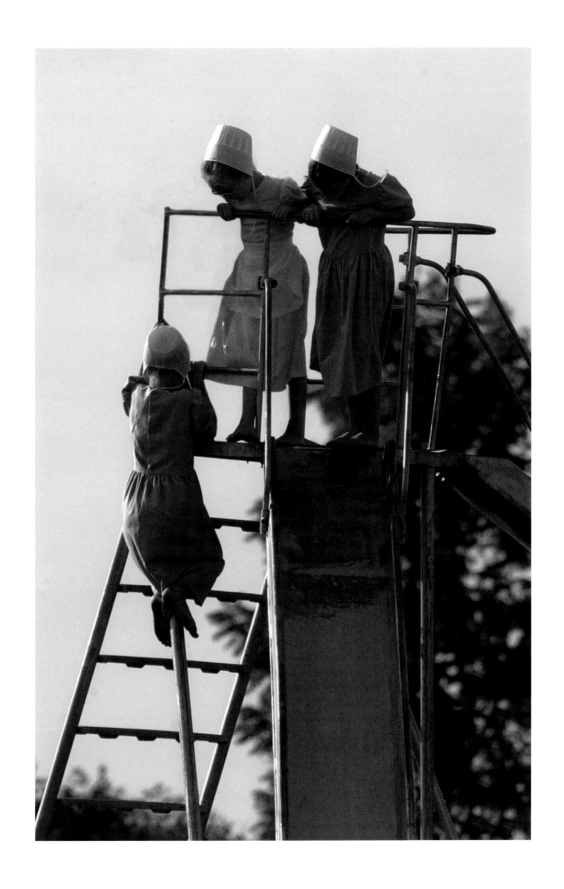

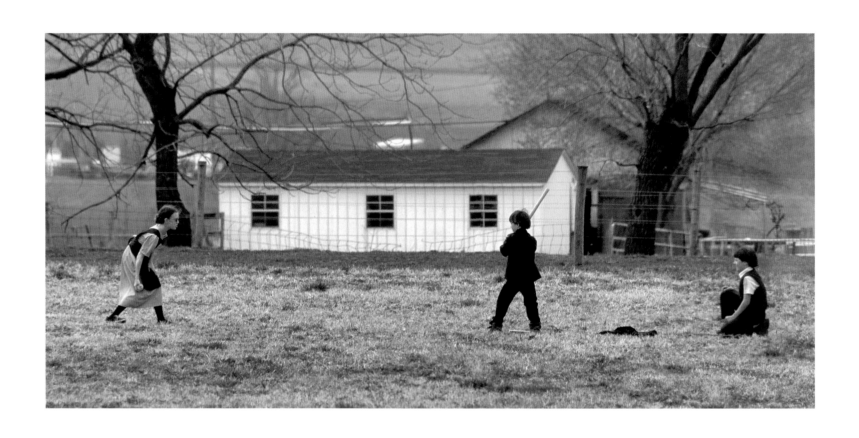

Amish 26_1, Lancaster County, PA 2001

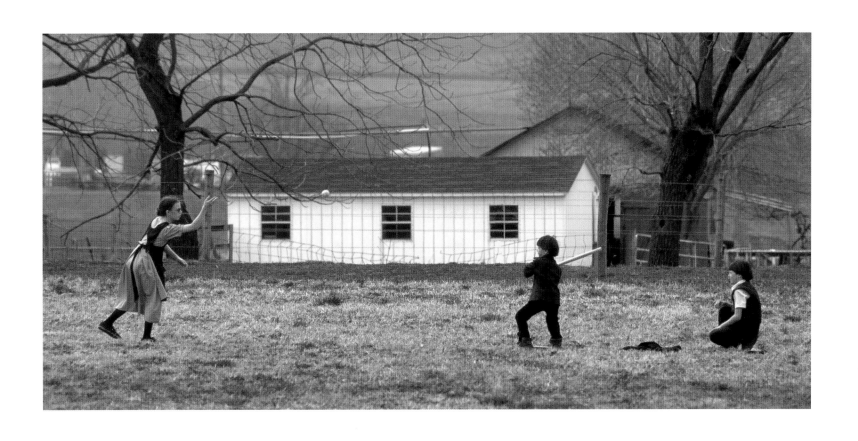

Amish 26_2, Lancaster County, PA 2001

Amish 57, Elkhart County, IN, 2002

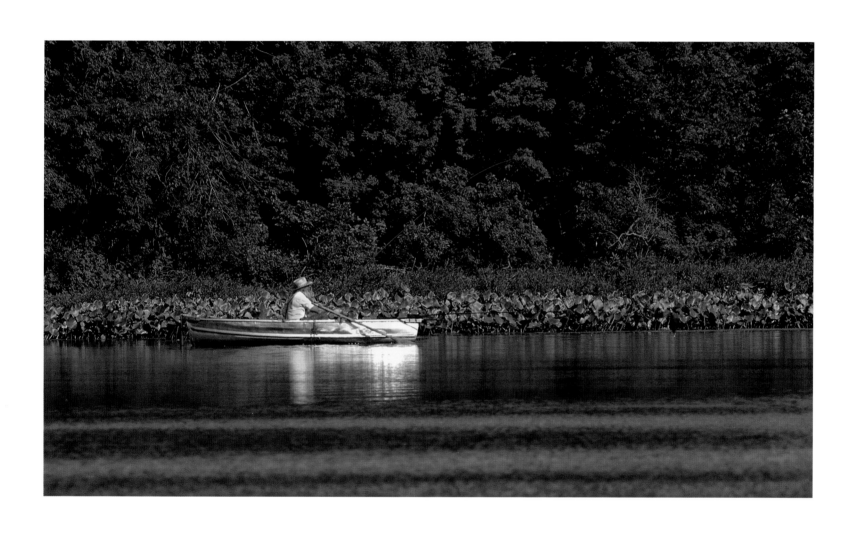

Amish 58, Elkhart County, IN, 2002

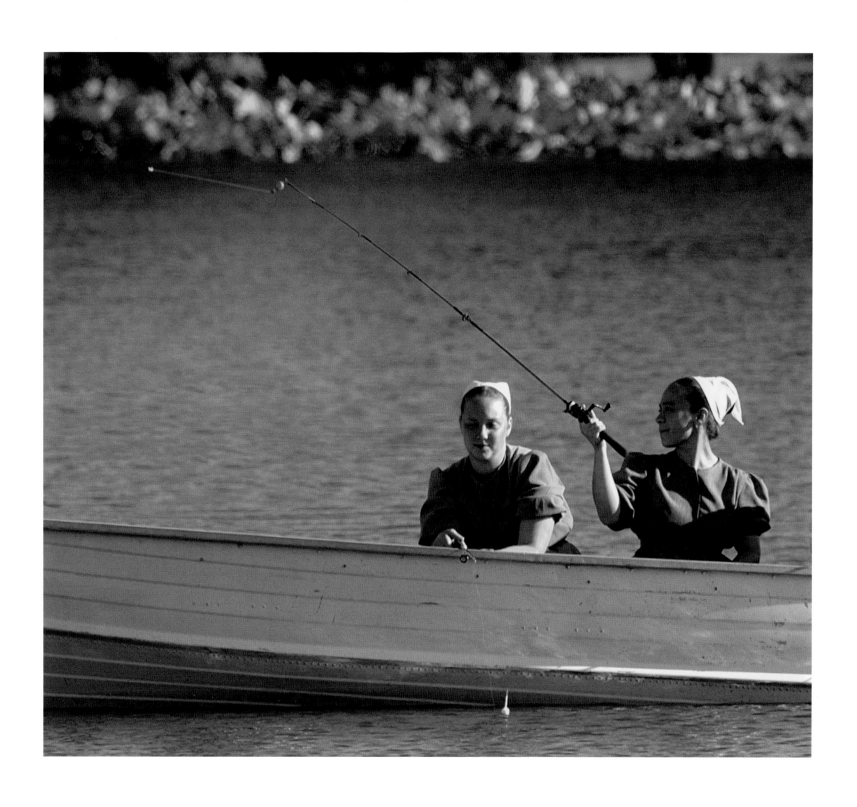

Amish 64, Elkhart County, IN, 2002

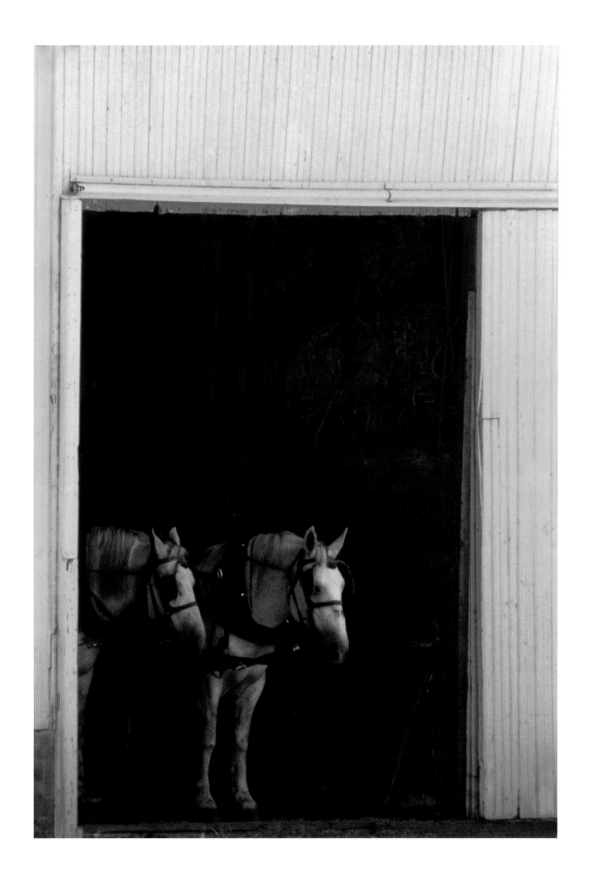

Amish 92, Bedford County, TN 2003

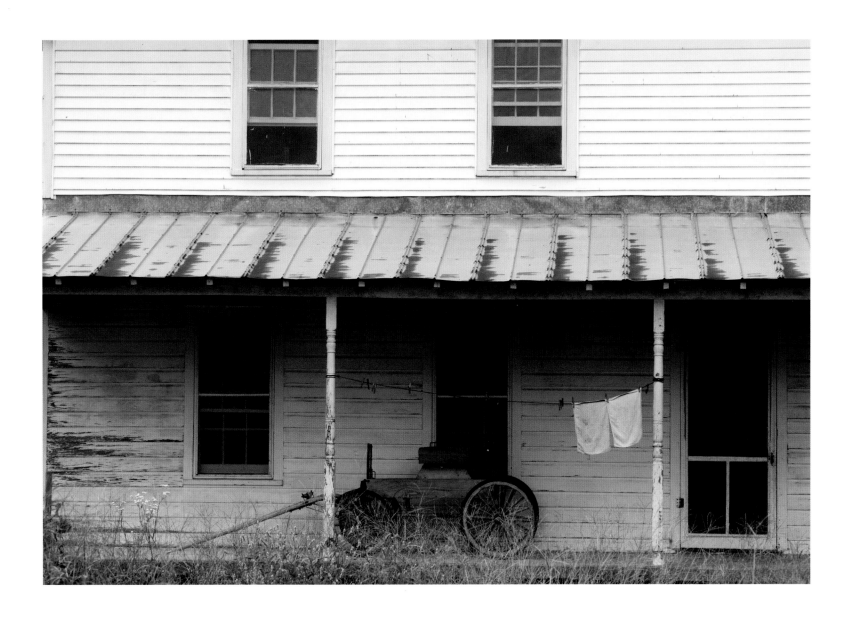

Amish 49, Holmes County, OH, 2002

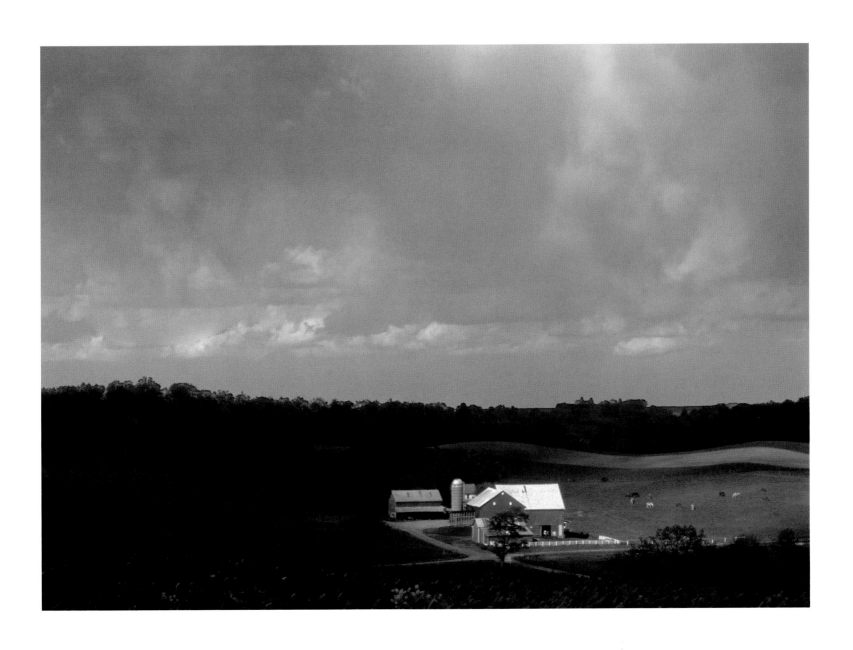

Amish 27, Lancaster County, PA, 2001

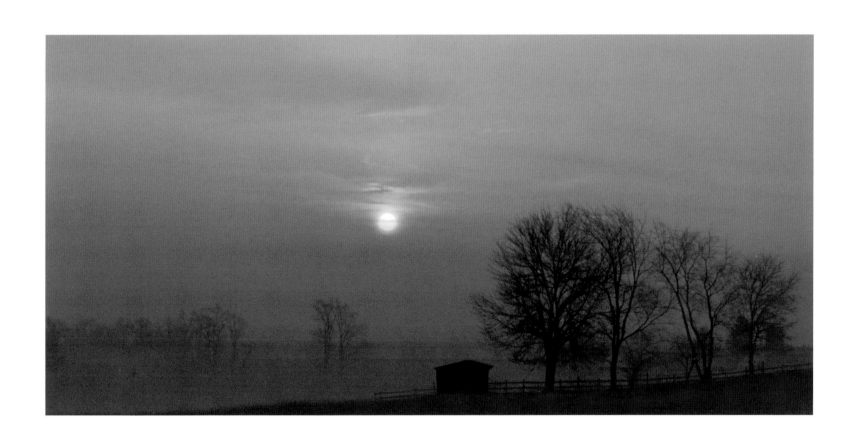

Amish 15, Lancaster County, PA 2001

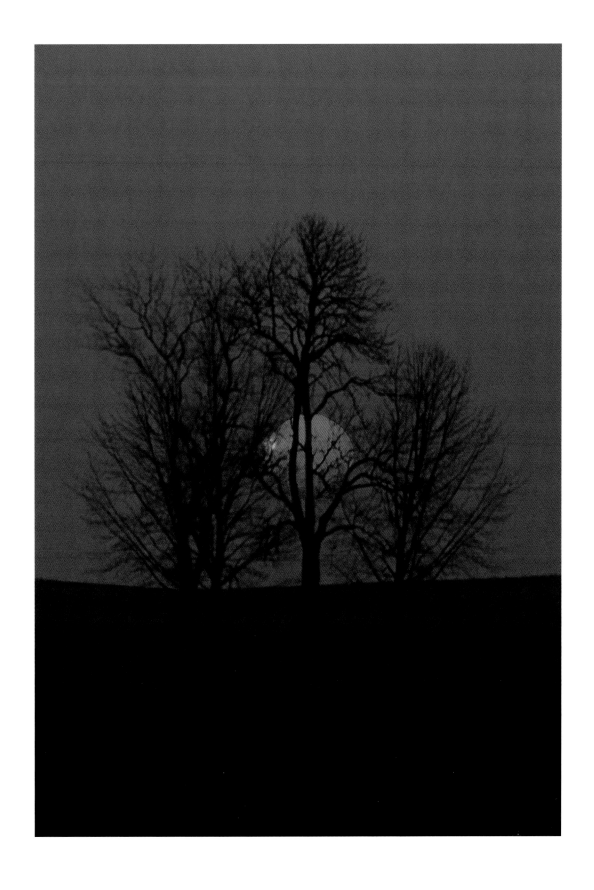

Selected Exhibitions

2004 Solo exhibition, *6:30 AM*, Santa Barbara Museum of Art, Santa Barbara, CA.
Solo exhibition, *6:30 AM*, Museum of Photographic Art, San Diego, CA.
Solo exhibition, *Another America*, Museum of Photographic Art, San Diego, CA.
Solo exhibition, *6:30 AM*, Craig Krull Gallery, Santa Monica, CA.

2003 *Wanderers, Travelers, and Adventurers*, Galleries of Mumm, Napa Valley, CA.
Images from the permanent collection of the Museum of Photographic Arts, San Diego, CA.
International Annual Center Awards, Center for Photographic Art, Carmel, CA.
Ansel Adams and His Legacy, High Museum of Art, Atlanta, GA.
California Color, Santa Barbara Museum of Art, Santa Barbara, CA.
Solo exhibition, *Landscape As Symphony*, Sidney Mishkin Gallery, Baruch College, NY.
Rhythm and Color in the Landscape, Benham Gallery, Seattle, WA.

2002 Solo exhibition, *Landscape As Symphony*, Edward Carter Gallery, New York, NY.
Inner Light, The Frederick R. Weisman Museum of Art, Malibu, CA.
Colour and Concept, National Gallery of Australia, Canberra.
11th Annual Center Awards, Center for Photographic Art, Carmel, CA.
Solo exhibition, *Robert Weingarten*, Benham Gallery, Seattle, WA.
Traveling Light, Museum of Photographic Arts, San Diego, CA.
Solo exhibition, *Robert Weingarten*, McLean Gallery, Malibu, CA.
Solo exhibition, *Robert Weingarten*, Craig Krull Gallery, Santa Monica, CA.

2001 Solo exhibition, *The Pastoral Landscape*, Weston Gallery, Carmel, CA.
Solo exhibition, *Intimate Vision*, Howard Schickler Gallery, New York, NY.
Water Forms, Galleries of Mumm, Napa Valley, CA.
Solo exhibition, *Robert Weingarten*, Ansel Adams Gallery, Monterey, CA.

2000 *10th Annual Center Awards*, Center for Photographic Art, Carmel, CA.
Solo exhibition, *American Landscape*, McLean Gallery, Malibu, CA.
Trees, HBO/Time Warner Gallery, New York, NY.
Intimate Landscapes, Tacoma Art Museum, Tacoma, WA.
Solo exhibition, *Quietscapes*, Henry Street Settlement, Abrons Arts Center, New York, NY.
143rd International Print Exhibition, Royal Photographic Society, Octagon Galleries, Bath, England.
It's About Time, Riverside Art Museum, Riverside, CA.

1999 *Earthscapes: Charlie Waite and Robert Weingarten*, Center for Photographic Art, Carmel, CA.
Americans in Spain, Paula Vincenti Gallery, Marbella, Spain.
Moving Toward the Millennium, Barnsdall Art Park, Los Angeles, CA.
Solo exhibition, *Paintings…through a Lens*, McLean Gallery, Malibu, CA.
25 Years of Photography, CEPA Gallery, Buffalo, NY.
International Landscapes, Mall Gallery, London, England.
Artists Council 30th Annual National Juried Exhibition, Palm Springs Desert Museum, Palm Springs, CA.
Solo exhibition, *Quietscapes*, Mayer, Brown & Platt, New York, NY.
Solo exhibition, *Quietscapes*, Sylvia White Gallery, New York, NY.

1998 Solo exhibition, *Quietscapes*, Sylvia White Gallery, Los Angeles, CA.
The Horse Show: Images of the Horse in Contemporary Art, Sylvia White Gallery, Los Angeles, CA.
16th Annual September Competition, Alexandria Museum of Art, Alexandria, LA.
Solo exhibition, *Quietscapes*, McLean Gallery, Malibu, CA.
Group exhibition, Sylvia White Gallery, Los Angeles, CA.
Light is Diverse in California, Center for the Visual Arts Gallery, Oakland, CA.
Realism 1998, Stage Gallery, Merrick, NY.

1997 *European Landscape Photography*, Christie's, London, England. Exhibition proceeds to benefit the National Preservation Trust.

Selected works on view at Marlborough Gallery, New York, NY; Weston Gallery, Carmel, CA; Craig Krull Gallery, Santa Monica, CA; and Benham Gallery, Seattle, WA.

Awards and Achievements

2001 Awarded the distinction Fellow of the Royal Photographic Society (FRPS), Bath, England.

2000 Awarded the Silver Medal for the Royal Photographic Society's 143rd International Print Competition, Bath, England.

1999 Awarded the distinction Associate of the Royal Photographic Society (ARPS), Bath, England.

1997 Awarded the distinction Licentiateship of the Royal Photographic Society (LRPS), Bath, England.

Publications

Camera Arts, "Landscape as Symphony," April–May 2002, pp. 14–19.
Royal Photographic Society Journal, May and June 2000, 143rd International Print Competition Award-Winning Images, Bath, England.
Earthscapes, exhibition catalogue, Center for Photographic Art, Carmel, CA, November 1999. Introduction by Dennis High.
Americans in Spain, exhibition catalogue, Paula Vincenti Gallery, Marbella, Spain, and Sylvia White Gallery, New York, NY, September 1999.

Selected Collections

Ansel Adams Home, Carmel, CA.
Frederick R. Weisman Museum of Art, Malibu, CA.
Frye Art Museum, Seattle, WA.
J. Paul Getty Museum, Los Angeles, CA.
High Museum of Art, Atlanta, GA.
Los Angeles County Museum of Art, Los Angeles, CA.
The Metropolitan Museum of Art, New York, NY.
Monterey Museum of Art, Monterey, CA.
The Museum of Fine Arts, Houston, Texas.
Museum of Photographic Arts, San Diego, CA.
National Gallery of Australia, Canberra, Australia.
Santa Barbara Museum of Art, Santa Barbara, CA.
Edward Weston Home, "Wildcat," Carmel, CA.
Whitney Museum of American Art, New York, NY.

Acknowledgments

While the creation of these images was a solo endeavor in the first instance, their realization as final prints and in book form took the dedication, hard work, and talent of others.

Chief among them is R. Mac Holbert, a founder and partner of Nash Editions, whose special talents were essential in refining and printing the final images.

Robert A. Sobieszek, Head Curator, Department of Photography, at the Los Angeles County Museum of Art, has been especially important in this project. His early commitment to this body of work was a vital source of inspiration. He curated a traveling exhibition of *Another America*, and sequenced the photographs for this book. I am eternally grateful for his thoughtful and lyrical essay for this volume.

I want also to thank Garrett White, who first brought my work to Steidl and produced and edited this book. His advice and assistance has been invaluable in moving this project forward.

My assistant Lila Durand devoted countless hours to handling all of the logistics with skill and grace in coordination with the publisher; a rare publisher indeed in today's world. Gerhard Steidl has shown great enthusiasm for this project from the beginning, and he and his talented staff have assured the quality of the finished product. Any artist would be proud to have him as a publisher.

I owe my most heartfelt thanks to the Amish people, whose lives apart from our modern world provide lessons in serenity and simplicity. I was blessed to be able to observe and record their lives in what I think of as "Another America."

I am also blessed with a loving family: my wife Pam, to whom I have dedicated this book, and who has a special affinity for these images; my children, Ilene and Marc, and my daughter-in-law Lynn, whose warmth and devotion are so meaningful to me; and my grandchildren, Samantha and Allegra, who represent tomorrow's America.

Robert Weingarten

Produced and edited by Garrett White, New York
Photo edit by Robert Sobieszek

Book design by Steidl Design

First edition 2004

Photography: Robert Weingarten

Copyright © 2004 for the photographs: Robert Weingarten
Copyright © 2004 for this edition: Steidl, Göttingen

Scans done at Steidl's digital darkroom
Production: Claas Möller, Gerhard Steidl
Printing by Steidl, Göttingen

Distribution: Steidl, Düstere Str. 4, D-37073 Göttingen
phone: +49-551-496060, fax: +49-551-4960649
www.steidl.de E-mail: mail@steidl.de
Orders can be placed directly at our publishing house.

ISBN 3-86521-011-2
Printed in Germany